LAST FOLIO

LAST FOLIO

TEXTURES OF JEWISH LIFE IN SLOVAKIA

Yuri Dojc and Katya Krausova

Photographs by Yuri Dojc

Museum of Jewish Heritage
A Living Memorial to the Holocaust
New York

Grunwald Gallery of Art
Indiana University Bloomington

in association with
Indiana University Press
Bloomington and Indianapolis

Publication of *Last Folio* was assisted
by a gift from Rita Grunwald in memory
of John Grunwald.

This book is a publication of
Indiana University Press
601 North Morton Street
Bloomington, Indiana 47404-3797 USA
iupress.indiana.edu

Manufactured in the United States of America

Cataloging information is available
from the Library of Congress

ISBN 978-0-253-22377-7

CONTENTS

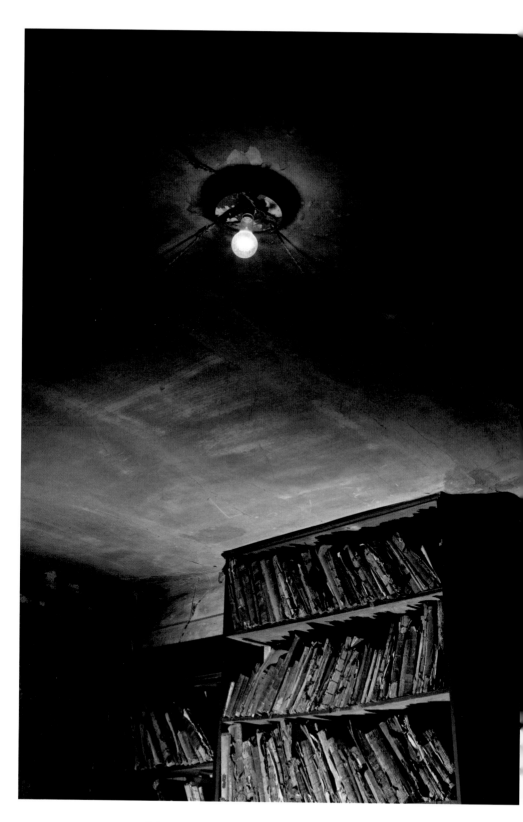

SCHOOLROOM Bardejov, 2006

Dedicated to the memory of our parents

Ľudovit Dojč and Regina Dojčová

Martin Kraus and Renée Krausová

to our children

Michael Dojc and Jason Dojc

Alexis Abraham and Natasha Abraham

and to the memory of

František Galan

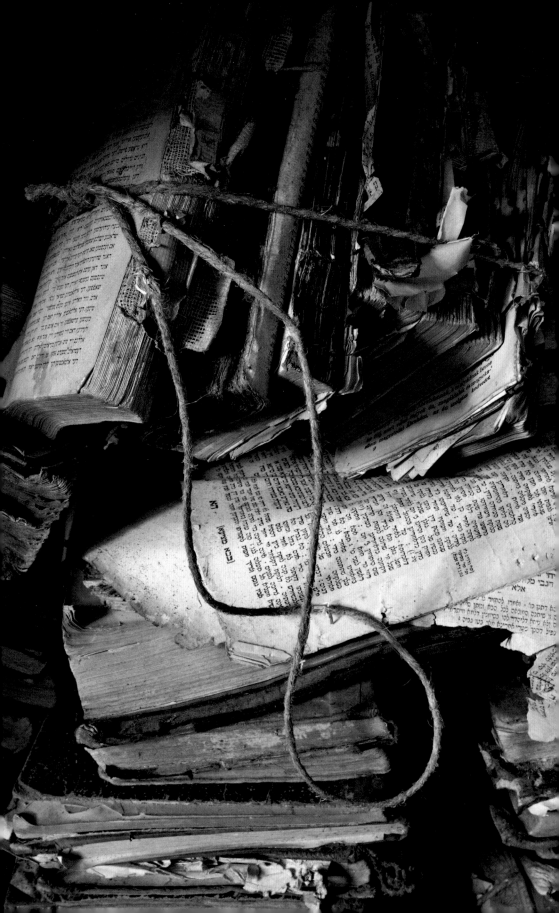

FOREWORD

*No foreign sky protected me, no stranger's wing shielded
my face. I stand as witness to the common lot, survivor of
that time, that place.*

ANNA AKHMATOVA *Requiem* (1935–1940)

In January 1997, at the funeral of his father, Yuri Dojc met a
remarkable woman, Ružena Vajnorska. She was one of the thousand
or so young Slovak girls who in early 1942 boarded the very
first train to Auschwitz.

She told him of her daily home visits to others who had survived
as she did. He asked if he could accompany her on her daily
rounds. She agreed. And so he began photographing these people
and the world they live in.

Chance led him to an abandoned Jewish school in eastern Slovakia,
where time had stood still since the day in 1942 when all those
attending it were taken away to the camps… The school books
were there still, essays with corrections, school reports, even
the sugar still in the cupboard… all decaying on dusty shelves, the
final witnesses to a once thriving culture.

All are treated by Yuri Dojc as the individual survivors that they
are — each book and fragment captured as in a portrait, preserved in
its final eloquence. One of them stands out especially: a book
that miraculously found its way from a dusty pile to its rightful
heir — a book once owned by Yuri's grandfather Jakub. And so a
journey which began with the portrait of his father came full circle.

In August 1968, Soviet tanks occupied Czechoslovakia and Yuri's
status as a summer student in London changed overnight to that

PRAYER BOOKS Michalovce, 2008

of refugee. A year later he moved to Toronto where he still lives. Four decades later he has earned considerable recognition for both his commercial and his artistic photographic oeuvre.

The current project, spanning more than a decade, of which this exhibition is a part, was first seen at the Slovak National Museum in Bratislava. A number of the images in the current exhibition are in the collection of the Library of Congress in Washington.

Daniel Weil's design of the Last Folio exhibition, evoking the books' skeletal remains with a never-ending light (*ner tamid*), provides the context for Yuri Dojc's photographs to become a celebration and commemoration of Jewish life in Slovakia.

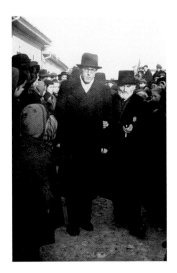
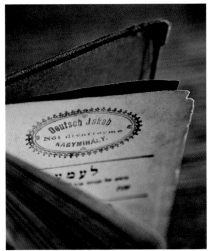

LEFT TO RIGHT

YURI'S FATHER AND GRANDFATHER AT HIS PARENTS' WEDDING 1942
BOOK BELONGING TO YURI'S GRANDFATHER, JAKUB DEUTSCH Michalovce, 2008

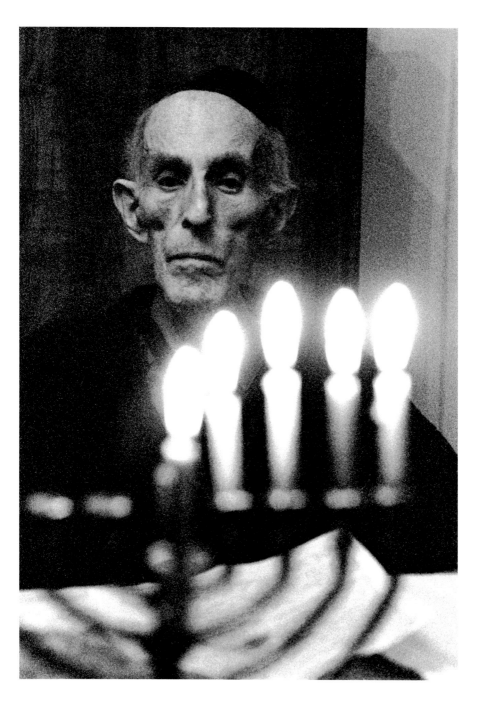

YURI'S FATHER, L'UDOVIT DOJČ Bratislava, 1996

ACKNOWLEDGMENTS AND SPONSORS

The list of those to whom we would like to express our true gratitude is almost as long as the five years that we have been working together on this project. Each deserves a mention, but before we list at least some of those who helped and encouraged us, we want to thank profoundly all those survivors who shared their stories with us, allowing us to capture their faces and record their testimonies for future generations.

This project was inspired by two very special people — Ružena Vajnorská, whom Yuri met at his father's funeral in Bratislava in January 1997, and František Galan, our contemporary, who sadly died too young. In his will František had asked Katya to identify a film project in Slovakia and dedicate it to his parents' memory.

We crossed the country many times and almost everywhere we met people willing to guide us, tell their life stories, accompany us to the remains of old buildings, or walk with us into the woods to find the many overgrown, abandoned cemeteries. Without them, much of what we have been lucky enough to capture would not be here.

Yuri's father's book — a compendium of Jewish religious communities in Slovakia — was with us on all our travels, our practical (and very symbolic) guide to many of the smallest villages, even hamlets. It provided another source of inspiration.

WE WISH TO THANK

In Slovakia

Ružena Vajnorská, Vanda Ujhazyová, Babula Frešová, Robert Haas, Paľo Traubner, Paľo Mešťan, Jozef Dukes, Peter Salner, Martin Črep, Juraj Levický, Betka a Tomáš Mittelmanovi, Cyril Bogoľ, Marcela Pošmorná, Peter Háber, Jan Gurník, Pipka Schicková,

Patrik Pass, Peter Zubal, Richard Krivda, Zuzana Chmelová, Vladimir Raiman, Zuzana Mistriková, Ľuba Lesná, Katarina Mathernová, Naďa Lovichová, Ľubica Adamcová, Slovak Ministry of Culture, UZŽNO-Slovak Jewish Community, Museum of Jewish Culture, Trigon Productions

In the United States

Lisa Walborsky, Rita Grunwald, Azar Nafisi, John Studzinski, Fern Schad, Paula Wardynski, Moshe Halbertal, Claire Frankel, Zuzka Kurtz, Steve Kimelman, Susan Mercandetti, Diana Negroponte, Caroline Stoessinger, Alan Fischer, Mark Allison, Stephanie Holmquist, Gideon Lichfield, Rose Schwartz, David Harris, David Gordon, Andrew Baker, Jack Rennert, Alice and Ted Cohn, Eva Vogel

David G. Marwell, Director, Ivy Barsky, Deputy Director, and the staff of the Museum of Jewish Heritage

Betsy Stirratt, Director, Grunwald Gallery of Art, Indiana University Bloomington

Janet Rabinowitch, Director, Indiana University Press

Abbott Miller and the design team at Pentagram

In the United Kingdom

Hannah Lowy, Parry Mitchell, Anne Webber, Alexis Abraham, Jan Saxl, David Abulafia, Janet Suzman, David Glasser, Jennifer Wingate, Maria Frederiksen, Lucia Faltin, The Lowy Mitchell Foundation, Eric Abraham, Pentagram

In Toronto

Eva Dojc, Mike Dojc, Jason Dojc, Maia Sutnik, Heather Reisman, Tiit Telmet, Sai Sivanesan, Olga Korper

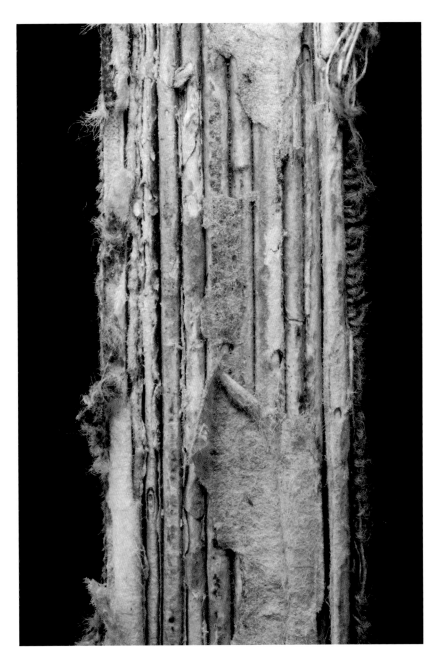

14

BOOK SPINE Michalovce, 2008

In Europe

Our many friends scattered around Europe who encouraged and supported us in many different ways, including:

Priscilla de Moustier, Claude-Noelle Finzi, Maria Luisa Montel, Irene Commeau, Annette Levy Villard, Fabienne Servan Schreiber, Michaela Spaeth, Christoph Bertram, Wolfgang Brehm, Wendelin Werner, Reiner Moritz, Anke Ritter, Christabel Burton-Galvano, Anna Skalická, Ido Bruno, Esti Knobel, Yaacov Lozowick

Finally, our thanks go to the inspirational Daniel Weil of Pentagram, whose generosity, vision, and design created an unforgettable experience for visitors to our exhibition in Cambridge and who continues the journey with us in the US and Europe.

SPONSORS

Last Folio is made possible by a leadership gift in memory of John Grunwald by Rita Grunwald.

Additional support provided by
a gift in honor of Mrs. Magdelena Szollos-Kallan by Henry Kallan,
Fern Schad and Alfred H. Moses,
the Shelley & Donald Rubin Foundation,
the May and Samuel Rudin Foundation,
and EPSON, Canada.

News Corporation is a media sponsor.

PHOTOGRAPHIC MEMORY

I believe that it is most fitting that this exhibition of Yuri Dojc's photographs should be inaugurated at the Museum of Jewish Heritage — A Living Memorial to the Holocaust — an institution that is dedicated to remembering those who perished in the Holocaust by celebrating their lives and exploring the legacy that they left. Consequently, our narrative is devoted not to how Jews were killed, but rather to how they lived. I can think of no better way to convey the tragic fate of Slovakian Jews, or to commemorate their lives, than to present these remarkable images. Yuri Dojc has focused his camera-eye with exquisite care, offering us evidence of lives lived that evokes a heartrending history.

Following the dismemberment of Czechoslovakia in 1939, the independent state of Slovakia was established. Closely allied with Nazi Germany and adopting its anti-Jewish policies, Slovakia was the very first country outside of Germany to deport its Jews. The first transport left on March 26, 1942, a trainload of nearly 1000 young women. There followed a succession of trains, nearly all to Auschwitz, which emptied Slovakia of almost three-quarters of its Jewish population within six months. Among those who were taken were the boys who attended a school in Bardejov. I cannot look at Yuri Dojc's photographs of the abandoned books from that school without imagining the people who left them behind. My mind's eye can see these boys closing and kissing their sacred texts and placing them down for the last time before they left forever. The photographs of these books, whose words once conjured worlds, show them as if they have turned to stone, frozen in the available light, petrified by the passing of time. There is no question that they have a certain power over us, and it is not simply their undeniable beauty.

While we have no way of knowing for sure, we can surmise that the last memories of the poor souls who were torn from their lives by Slovak police and paramilitary were populated with images of

the kind that Dojc has captured — people, places, and things — the basic elements of life distilled. In the bleak monotone of the cattle car and the sickening fear that engulfed them, one can imagine that they found comfort in calling upon such images of normal life. Indeed, our memories can produce vivid pictures from our past — like photo albums — that can link by reflection to other times.

It should come as no surprise that when we think or talk about memory, we often resort to photographic metaphors. After all, our memories are, for the most part, delivered to us as images that play in our minds. Indeed, psychologists have tied certain memory phenomena explicitly to photography. Consider eidetic or "photographic memory," which describes the phenomenon of total visual recall, or "flashbulb memory," which refers to vivid recollections of particularly meaningful experienced events (we all remember where we were on 9/11). It is believed that, under certain circumstances — often those associated with traumatic events — memories can be fixed into a vivid photographic permanence.

In the context of the trauma of the Holocaust, Dojc has delivered hauntingly beautiful images — jewel-like tokens — that link us by imagination to a lost world and time. Somehow in looking at them, we can "remember" all they represent. Our uniquely human capacity for empathy and understanding is triggered, and we are transported inward to a world that is animated by our collective memories. As we look at these images of all that remained, we remember all that was lost.

DAVID G. MARWELL
Director
Museum of Jewish Heritage
A Living Memorial to the Holocaust

KATYA KRAUSOVA

Bratislava, November 2005

I'm meeting Yuri at the airport, he has flown in from Toronto, I from London. We are to start filming survivors the very next morning with a Slovak film crew. We have ten days, many people to see, and much ground to cover. We have no inkling what awaits us.

At Yuri's suggestion we start with the first person he photographed, nearly a decade ago, the woman who "got him started on this path": Mrs.Vajnorská. "Don't ask her this, don't ask her that, don't be pushy with her," Yuri warns me, and under no circumstances mention her activities in Auschwitz as a camp guard.

When she finally walks into her sitting room, the first thing she says directly to the camera is: "You need to know that I was a KAPO, a camp guard, at Auschwitz."

We try to interview her brother next — Mr. Blau — a man once handsome, elegant, now bent, left with only fragments of his memory. But for me those fragments are so very precious: he remembers my mother's father as well as my father, with whom he served in the same army unit.

Mr. Blau is living in the Jewish old people's home where we also find Mrs. Lipschitz, who is nearly 100 years old. She talks about the Christian family that hid her and whose grandchildren and great grandchildren were, until very recently, looking after her. She is the first of a number of the survivors who talk with enormous grati-tude and admiration about the people in the Christian community who risked their own lives to save Jews.

19

A couple of days later we arrive in Hodonin and Yuri remarks that when he last visited Mrs. Grünstein, he felt unable to capture "her spirit" in the photo he took and hoped for a better picture this time. Katka Grünstein begins to talk about her almost idyllic childhood

and youth in Senica. And then about the day when, as a student at the Teachers' Training College, she was called into the Director's office and told that, because of the new "racial laws," she would not be able to continue. "My world collapsed in that moment," she recalled.

In March 1942 she found herself with a thousand others on the "girls" train from Poprad Railway Station to Auschwitz. She lived through all the horrors, but nothing in those three years had prepared her for the final episode, the Death March. "I just wanted to die, I asked the guards every day, please shoot me"— but it was not to be.

They hung on to life, but only just. "That was the end," Mrs. Grünstein repeated several times. "We spent a long time in ditches on the side of the road, as the Allies bombed the road during the day, and we were made to march at night. And then suddenly one day the Germans were gone — absolutely gone — that was when we realized the war was over."

"We just collapsed into the ditch and I do not remember if I slept 5 hours or 5 days. When I woke up, surrounded by bodies, some dead and some sleeping, I thought I heard some Slovak being spoken nearby, but I really did not know if I was dreaming. So I tried to concentrate and focus on what I was hearing, and though I did not see the people talking I finally realized that two men were indeed talking in Slovak, talking about the future of Czechoslovakia, the reconstruction of society — they were talking like the past three years had not happened."

She found her girlfriend, thankfully also alive. They joined the two Slovaks and their group, knowing that somehow they had to make their way to Lübeck from where the Red Cross would repatriate them back to Czechoslovakia. The journey took almost

two weeks. They were hungry and weak, there was no food, there was looting, there were soldiers on horses shooting into this pathetic crowd of skeletons, some died eating raw potatoes. But the group she was with was being led by one of the men whose voices she had heard and he seemed to have an extraordinary ability to look forward, to have the will to live, to make plans for the future, even though none of them knew for certain that their bodies would get them to Lübeck. They slept in abandoned houses, cowsheds, forests — and made it to Lübeck.

In those two weeks Mrs. Grünstein came back to life. "I was a young woman and I fell in love. Although we looked dreadful, we had not washed for months, still I could feel life coming back into my body." "So did you marry him?" I asked. "No," she replied, "I lost contact with him in Lübeck. I looked for him and waited for some time. In the end I married someone else. I only met him again many years later, after he had spent years in prison." "Do you remember his name?" I asked. "Yes, of course," she replied. "His name was Martin Kraus."

I knew her answer almost before I asked the question. I had heard the story of the final walk to Lübeck in all its details. "That was my father, Mrs. Grünstein." I uttered this in a state of electrification. She looked hard at me and said: "Come here, little Krauska, let me look at you! I could have been your mother, you know!"

How do you describe that moment when the threads of history suddenly cross, you meet a witness of a part of your life — here was someone who confirmed what I knew about my father all my life — his unstoppable will to live, his energy for life.

This accidental meeting changed the dynamics of our little group. We were no longer making a film in which people talked about their past. We were talking about our present.

We reached Bardejov, once a popular spa town on the Polish-Ukrainian border. We came to film the grand synagogue complex, now a hardware store and warehouse. Its beautiful ceiling arches are cracked, the frescos are deteriorating, birds have built their nests under the roof. Outside is a faded plaque which tells us that 3,700 Bardejov Jews were taken to the camps directly from the synagogue in 1942.

In a typical prefab council block we visit the last Jewish couple still living in the town. Mrs. Šimonovič, who has a strikingly beautiful face, tells us, first reluctantly, then in great detail, about her father who was the kosher butcher here before the war. She ends by saying that she never wanted to talk to anyone about her wartime experiences, but now she feels, at the end of her life, that it all needs saying. This is a phrase we heard time and time again. I remember Mrs. Grünstein's parting words to us: "I am so pleased you want to hear all this, I always wanted to tell my story to someone."

We are about to leave the building when a neighbor invites us to his flat. He has something to tell us, but... "not here in the lobby." This is at a moment that happens to all film crews everywhere. It has been a long day, a long drive, they have had enough. They just want to go back to their hotel, have a beer, and not hear anything anymore. But we are persuaded to get back into the rickety elevator, go to the 7th floor, remove our shoes again, and crowd into the small sitting room, while the wife offers tea, wafers, and slivovitz — kosher, she says.

Mr. Bogol' tells us that he is the warden of the Protestant church, that he and his wife have lived in the same block with the Šimonovičs more than 40 years and that following the death of Mrs. Šimonovič's brother, he has become the keeper of the

22

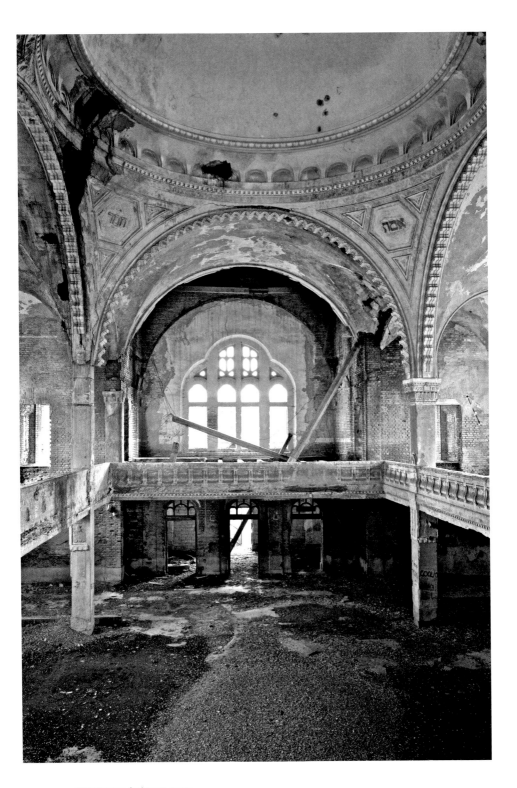

SYNAGOGUE Lučenec, 2010

keys of a building in the town. He is adamant that before we leave in the morning we have to see it. I decline as politely as I can. We have a tight schedule, there is another old survivor waiting for us 300 kilometers away, and there is a lot of snow on the roads.

At five to eight in the morning I see Mr. Bogol' pacing outside our hotel. "Just 10 minutes," he pleads, "though you should see the cemetery as well. I have been looking after it and have counted and numbered over 5,000 graves." "Next time," I say, feeling guilty and graceless.

We follow his car and park somewhere behind the jewel-like main square. He opens the doors of a building in a row of houses. Two tall windows and a sign in Hebrew above them, but otherwise there is nothing to attract attention to the house front. We walk in at five past eight in the morning and next time I look at my watch it is well after two in the afternoon.

Time stopped still in this building, which housed a Jewish school a long time ago, almost certainly in 1942, the day when Bardejov Jews vanished forever. Mr. Bogol' proudly shows us how he and his wife have been painstakingly cleaning each bench, each light, each seat, finding — and preserving — every object, religious or otherwise. Even the spittoons are in what must have been their original places by the old chimney in the corner, the books are on the shelves, the two long benches with writing desks in front of them are empty, there are Hebrew inscriptions on the walls. Mr. Bogol' is talking to me but I can hardly hear him. The place is haunted by children's faces."

Yuri and the cameraman are unable to move away from the bookshelves. The disintegrating tomes, the beautiful, decaying spines, all the crumbling pages are mesmerizing. They speak

volumes about those who never came back to read the texts,
to explain, to teach, to learn from them. On his return to Canada,
Yuri phones me: "I have to go back, I am looking at these
photographs, and I don't understand what I was looking at, I
have to go back, soon!"

September 2008

Three years later and numerous visits to the Bardejov schoolroom
later, we are told of another place that houses books. We go. Yuri
is taking pictures of tefillin straps while there is daylight, as there
is no electricity in the house.

I am struck by all the name plates and stamps of the owners
of the books, and I recreate the small town in my mind's eye: the
doctor, the butcher, the bookseller even the man who only
sells "exotic sweets." I suddenly come across a book stamped with
the name Jakub Deutsch. I walk into the next room, reflecting
that so many years into the project we have never really talked
much about the fate of our own families.

Deutsch is a very common name in central Europe. "What was the
name of your grandfather," I ask. "Jakub," he says. "And what
did he do?" "He was a tailor, women's fashions…in Michalovce.
There it is in Hungarian—Yuri's grandfather's book. I hand
him the book. We stand in stunned silence. We have finished our
project, completed our journey.

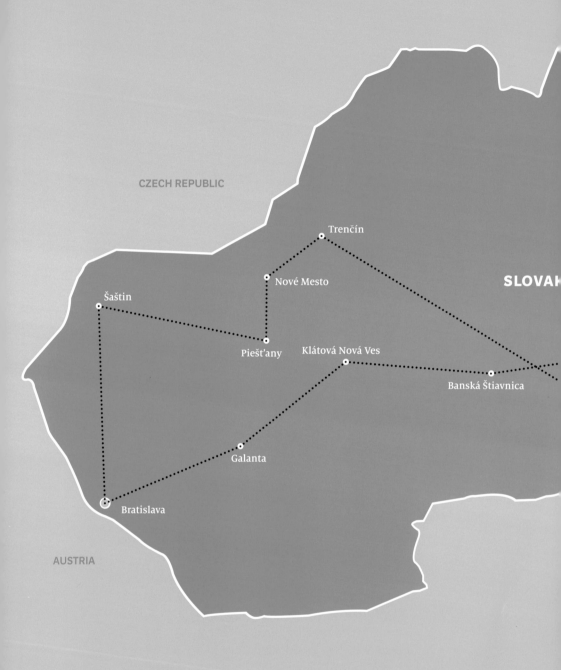

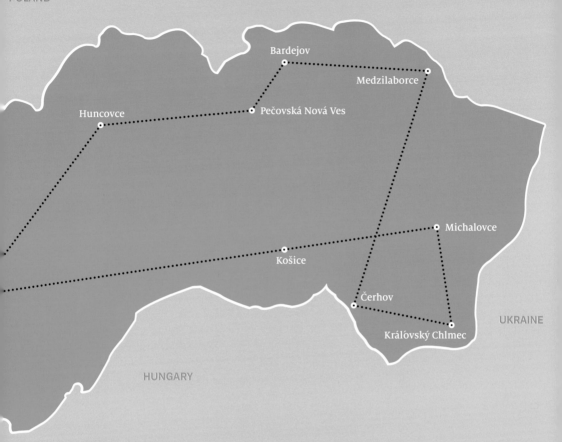

POLAND

Bardejov

Medzilaborce

Huncovce

Pečovská Nová Ves

Michalovce

Košice

Čerhov

UKRAINE

Králóvský Chlmec

HUNGARY

LOCATIONS OF PHOTOGRAPHS

AZAR NAFISI

The dead speak to us, and through us. They can come back as fact, or they can come back as fiction. The trick, I think, is to face them, to channel their force, to write through and with one's grief. To lend them your pen so that you can let go of their pain.

OMID, BOROUMAND FOUNDATION
Website for the promotion of democracy in Iran

I have returned time and again to Yuri Dojc's photographs of Holocaust survivors, ruins of schools and synagogues and books that were abandoned when one day in October 1942, their occupants were interrupted in the middle of their everyday routines and taken to concentration camps — the most moving evidence of their existence are the books and notebooks they left behind. The Roman poet Virgil had said that "Objects have tears in them." It seems to me that these books survived for over six decades so that we will not forget the tears.

My first response to these photographs was a sense of immense tenderness, the desire to gather them into my arms, the way we feel about children, beloved pets, very old people, creatures whose silent gaze draws us in, whose intense fragility is their only weapon and protection against life's cruelties. This combination of frailty and perseverance made me want to protect them and in a strange way to be protected by them.

Books in these photographs are not mere objects, they are possessed by spirits exorcized through Yuri Dojc's magical eye: as they disintegrate into dust, the camera illuminates how that moment of disintegration is also a moment of immense energy and movement, one last and glorious statement of defiance, resisting both death and oblivion. They are alive, appearing in so many

29

forms, as if they have now taken on the shapes of feelings and
emotions of those who owned them, becoming conclusive evidence
of their existence. They are dancing dervishes, black holes,
musical notes, slabs of light, the falling time. It is their presence
as books that articulates the vanished lives of their owners.
Now that they no more present life through words, they reveal it
by taking on different forms of life, reminding us how at the
very moment of death there can be that irrefutable confirmation
of life, the refusal to merely submit to death and forgetfulness.
This miraculous transformation has taken place because of Yuri's
art, his alternative eye, his passion that will now bring to us
those forgotten lives, reminding us that metamorphosis is at the
heart of life and of art.

I believe that Yuri Dojc was guided by the spirits of the victims
when he started his search for his family's lost past; he was
chosen as their messenger, their ambassador. How else can one
explain the amazing coincidence when, among hundreds of
decaying books, his friend and colleague, Katya Krausova, discovered
the one belonging to Yuri's grandfather, a tailor named Jakub?
It is good that the past is so stubborn, that it refuses to go away, that
there are so many ghosts intruding upon our lives, making us
pause, demanding attention as well as justice. These ghosts, like
poets and artists, are wanderers, defying boundaries, roaming
the globe, claiming the whole world as their home, making sure
that the truth will be revealed. And truth knows no boundaries of
time and place and is always a call to action, because once we
know what has happened we become implicated and responsible,
no more able to plead ignorance.

How do we avenge the injustices committed against those who
have been denied the right to defend themselves? Politics alone,

even in a democracy, cannot be and has not been the sole defender of justice. We cannot only bury the dead but we also need talk to them, communicate with them, learning not just about who they were, but also who we are, and what we as human beings are capable of, in the worst and best sense of the term. It is in this manner that we empathize with those whose lives were interrupted on that far-away and yet not-so-distant day in October 1942. Safeguarding their memory is in itself a form of justice, not only against the brutality of man, but also against the cruelty of time, a reminder of what Tzvetan Todorov had said so eloquently about the victims of concentration camps and gulags: "Only total oblivion demands total despair." What happened in that small town in Slovakia now belongs to us all, part of our universal memory.

I believe the spirits that guided Yuri Dojc wanted the world to know not just what had happened, the unspeakable, intolerable atrocities and carnage, but to understand that what we call resilience of the human spirit is not a mere fable. As in all great art, Yuri Dojc's photographs mourn the tragedy of those lost lives, but celebrate them as well, and in doing so they, like the poet Dylan Thomas, affirm that "Death shall have no dominion."

The German thinker Theodor Adorno asked: Can there be art after Auschwitz? These photographs, in their anguished beauty, assert that there will always be art after Auschwitz, because there will always be life, and that art is ultimately on the side of life. I believe this is the message the spirits guiding Yuri wanted us to know. Consider this: Yuri, who did not photoshop the photos and did not know Hebrew, had in one photograph randomly taken from a shelf and moved outside into the light the only visible text on the ruined leaves of a page: the text read "Hanishar"—"the remains."

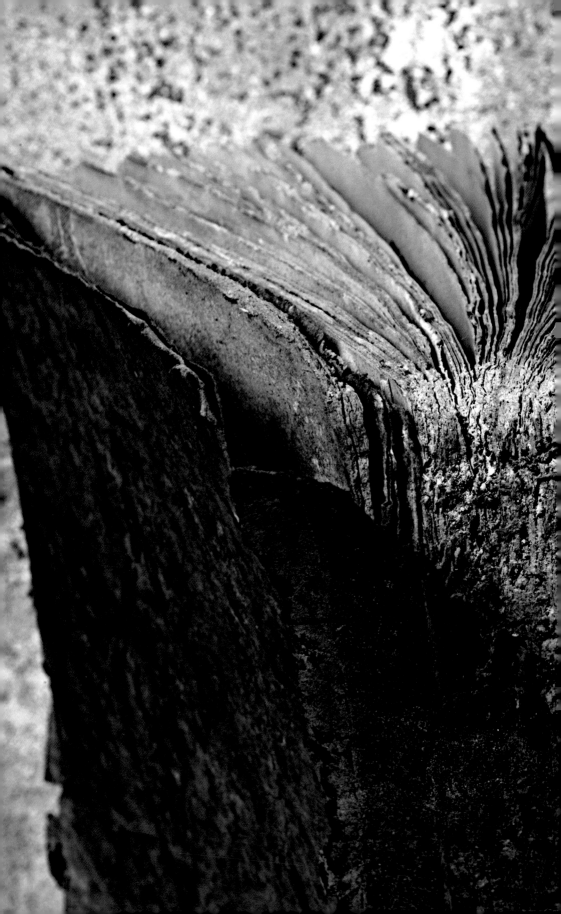

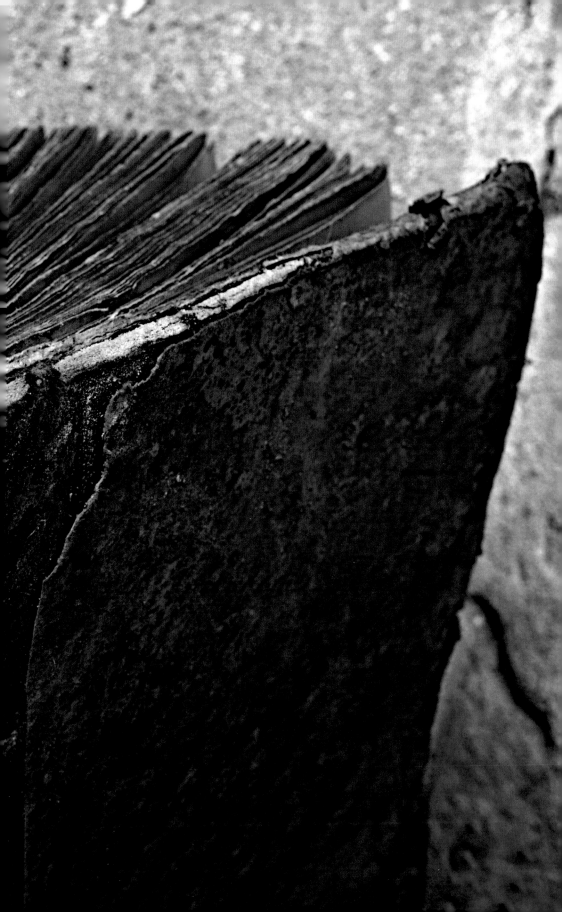

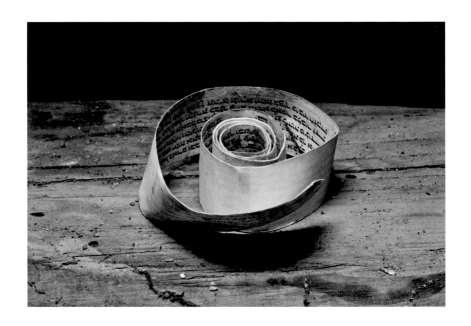

LEFT TO RIGHT

TEFILLIN SCROLL Bardejov, 2006
TEFILLIN Bardejov, 2008

PAGES 32–33

BOOK SPINE Bardejov, 2007

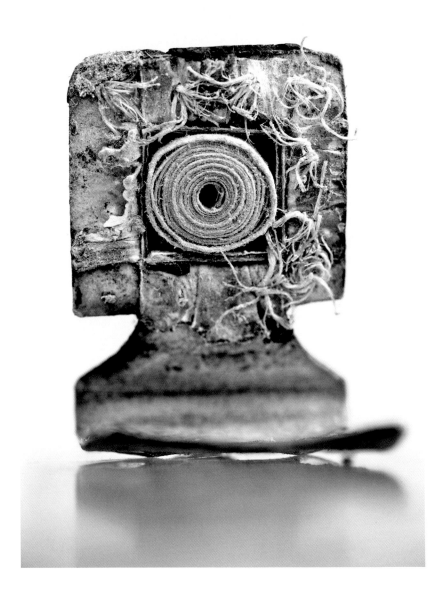

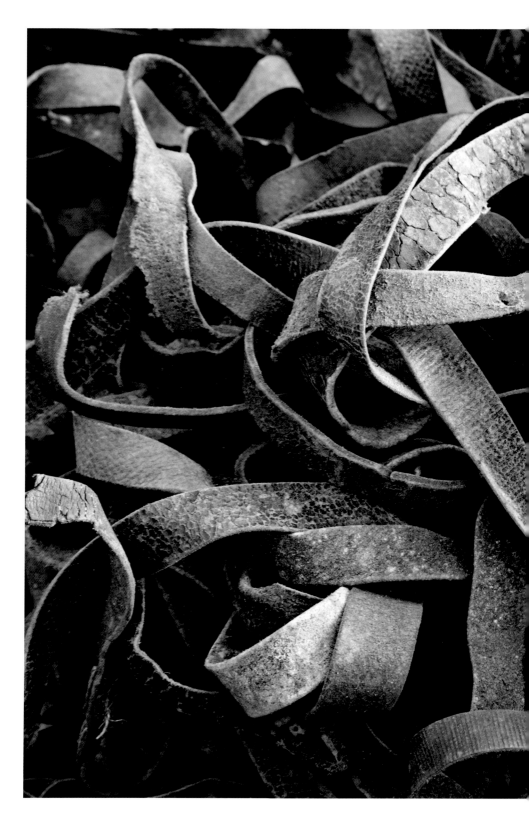

TEFILLIN STRAPS Michalovce, 2008

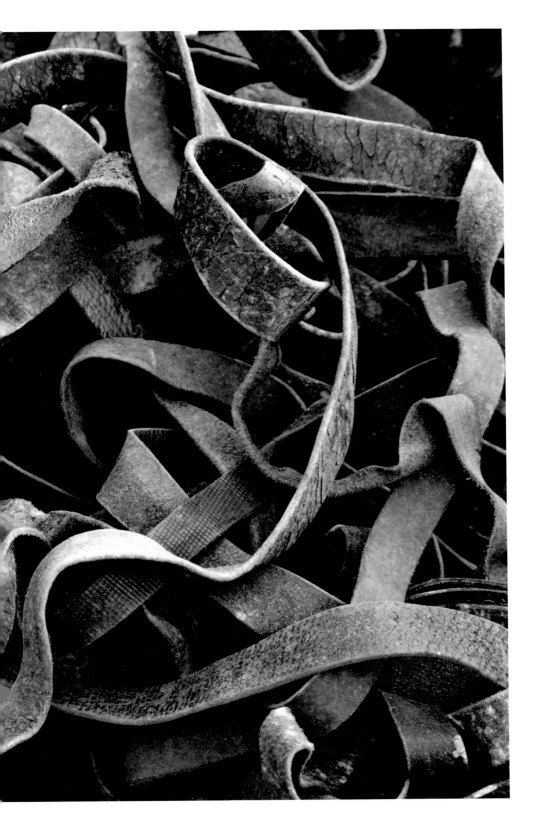

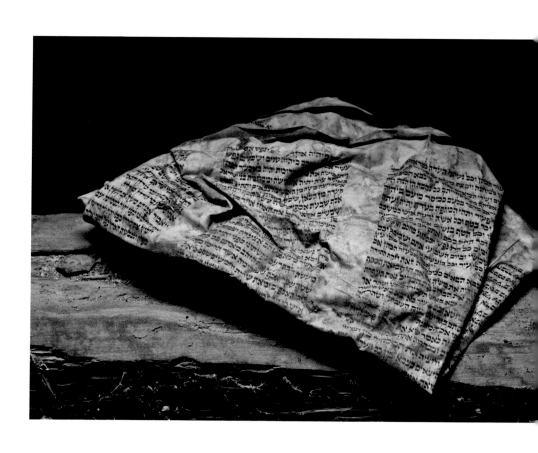

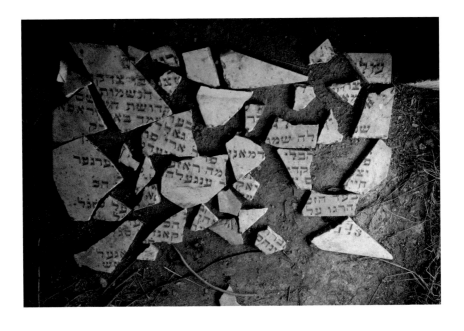

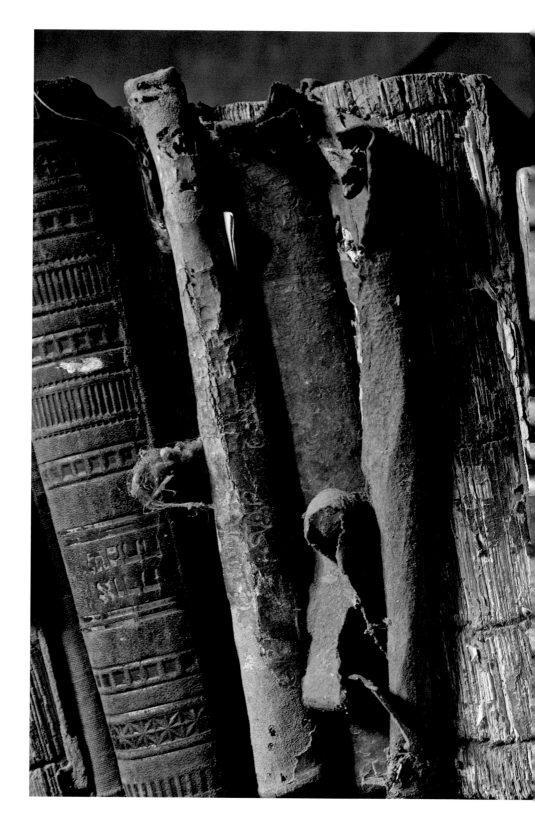

BOOKSHELF Bardejov, 2006

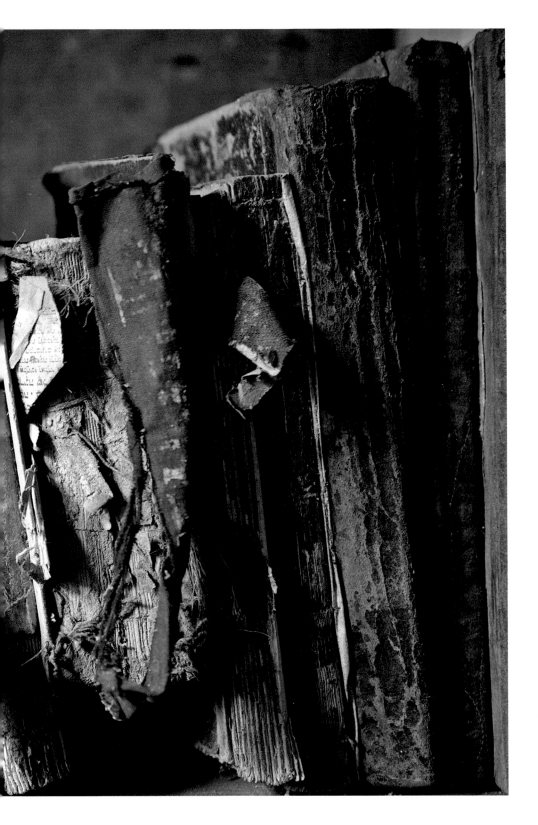

LEFT TO RIGHT

BOOK FRAGMENT Lučenec, 2010
BOOK Bardejov, 2007

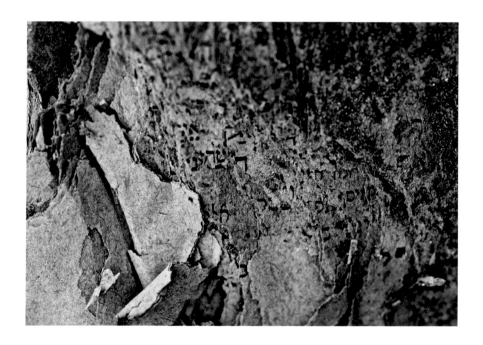

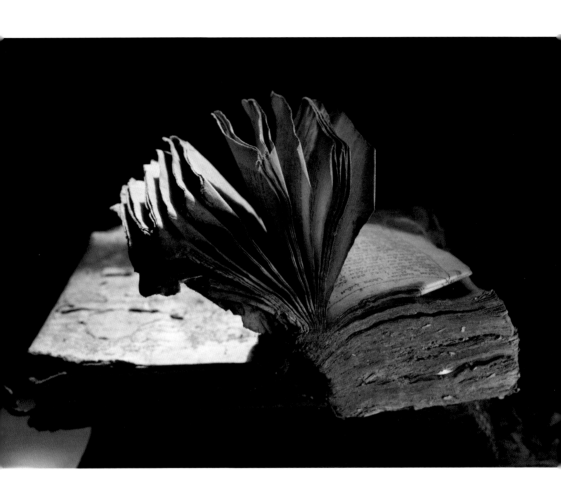

BOOK FRAGMENT Michalovce, 2008

PAGES 46–47

BOOK FRAGMENT Bardejov, 2008

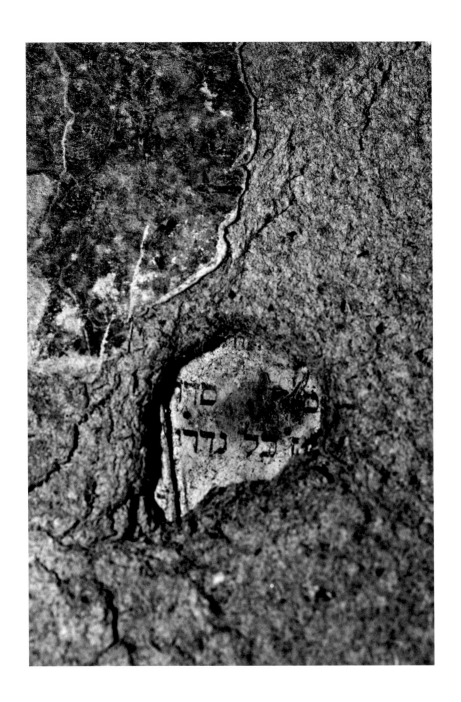

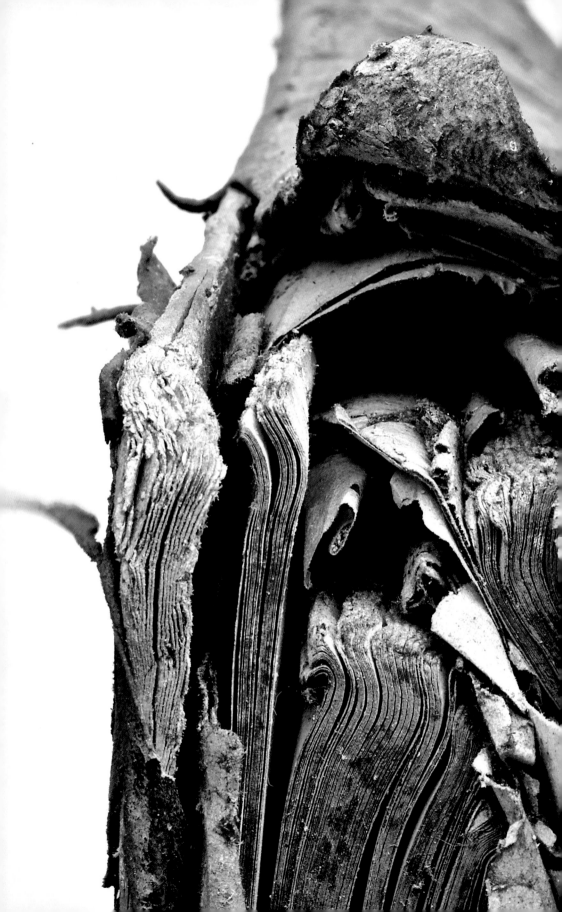

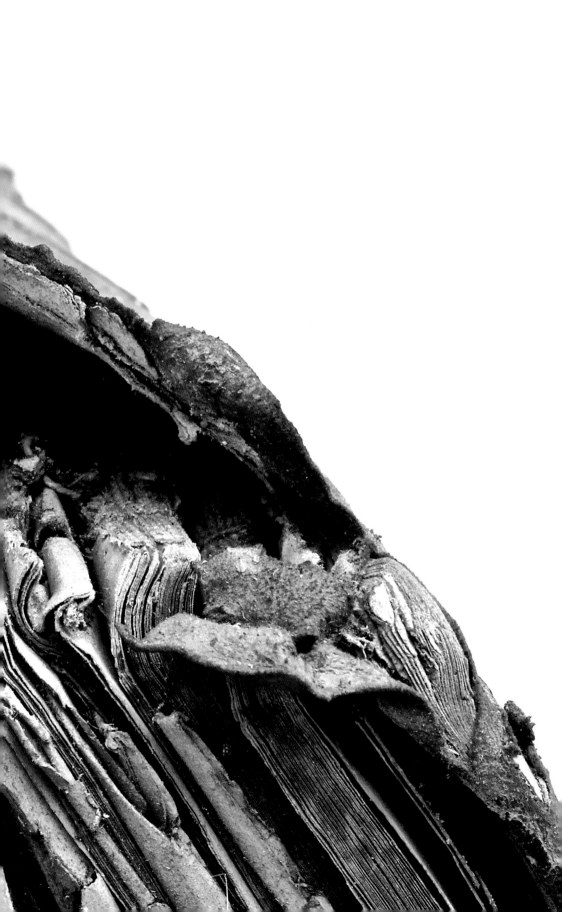

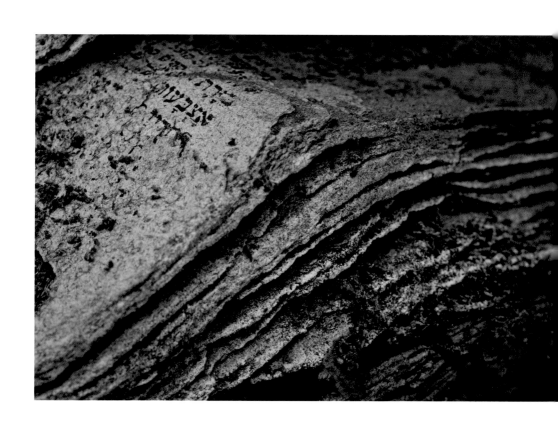

LEFT TO RIGHT

BOOK FRAGMENT Lučenec, 2010
TORAH SCROLL FRAGMENTS Košice, 2007

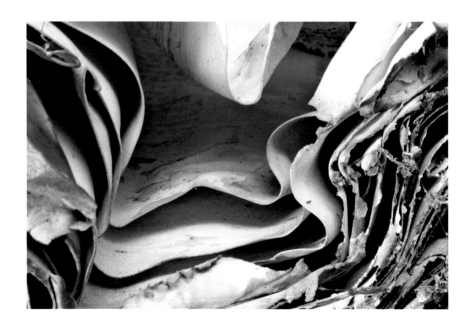

TORAH SCROLL Košice, 2007

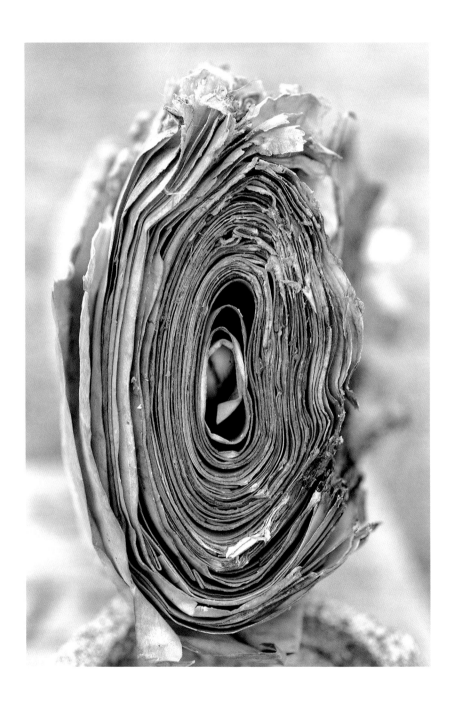

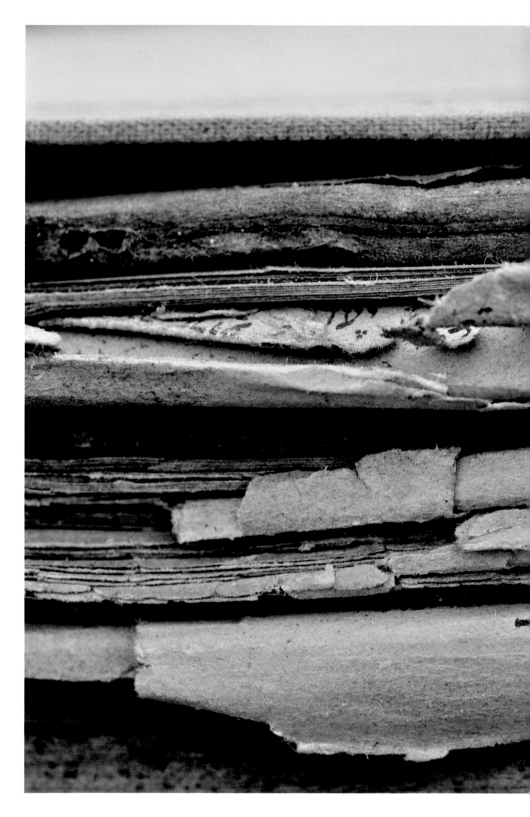

BOOK SPINES / HANISHAR Bardejov, 2006

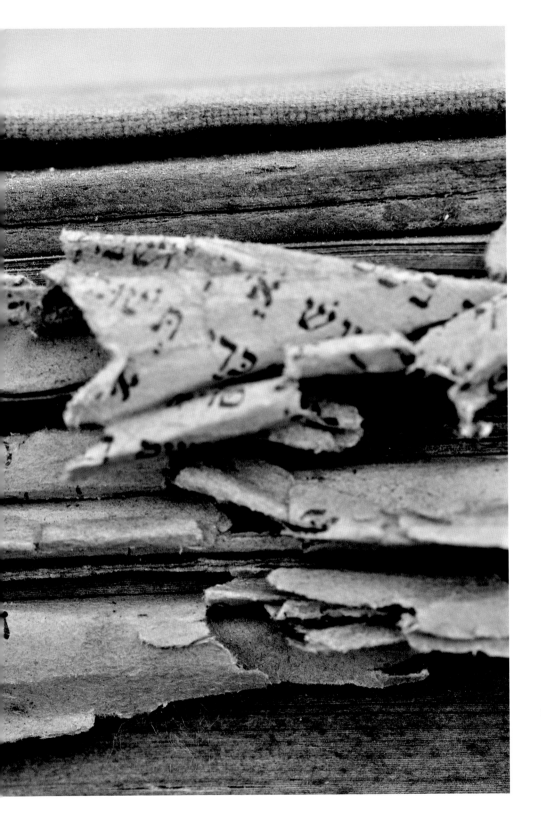

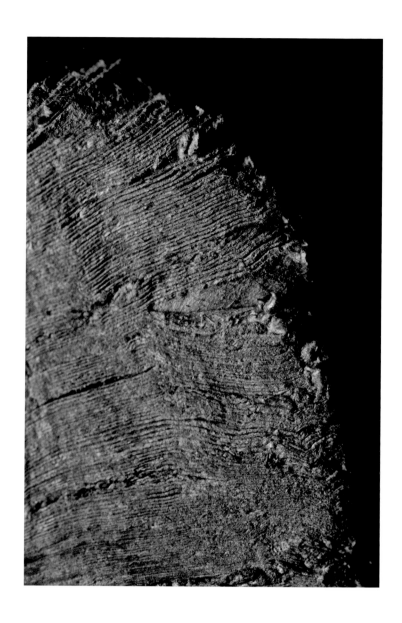

54

PAGES 56-57

BOOK FRAGMENTS AND SPINES Bardejov, 2008

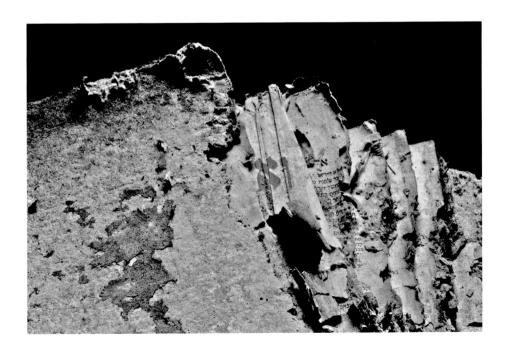

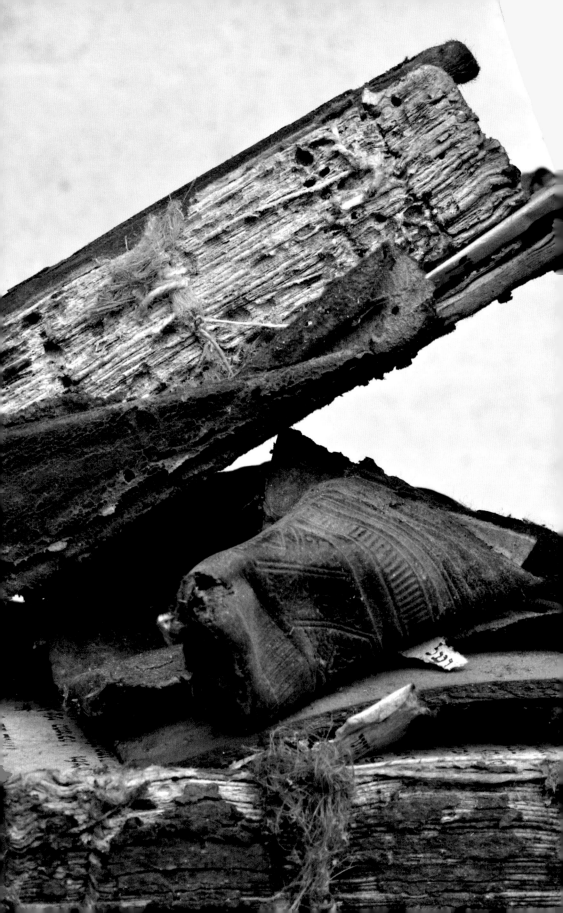

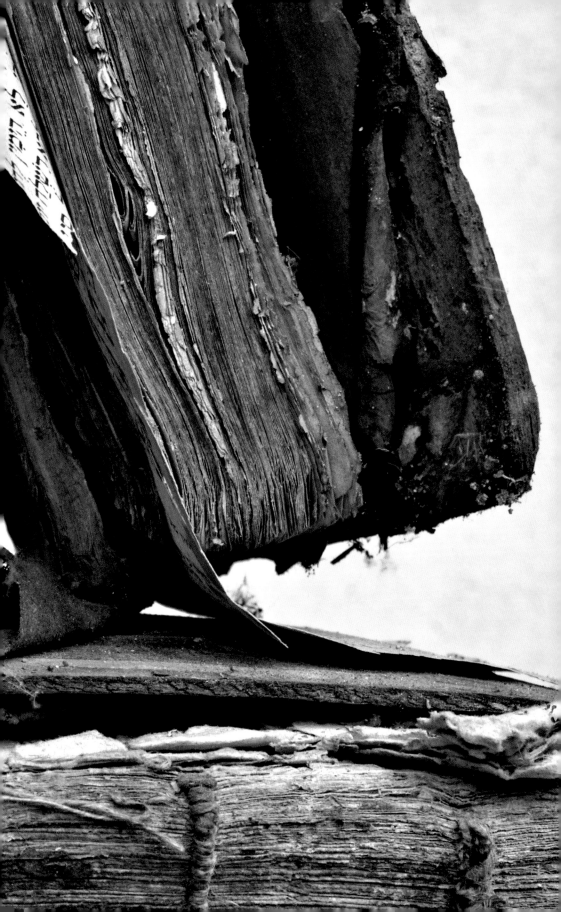

MIKVAH Bardejov, 2006

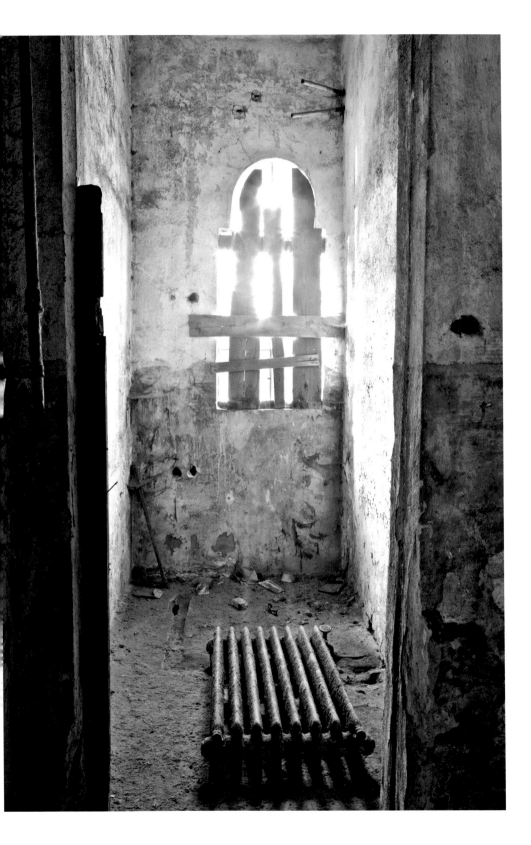

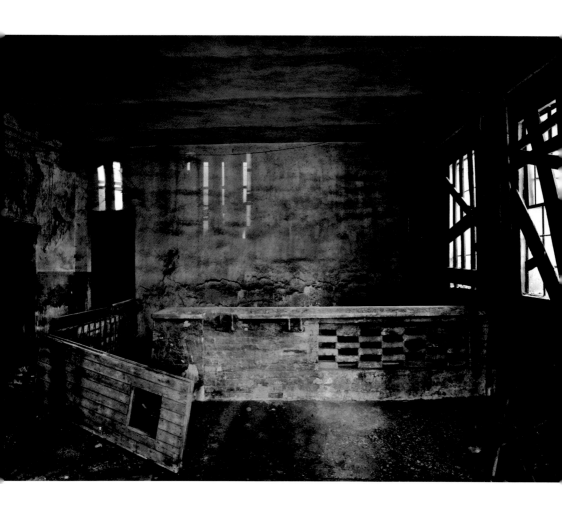

LEFT TO RIGHT

MIKVAH Bardejov, 2006
MIKVAH Bardejov, 2006

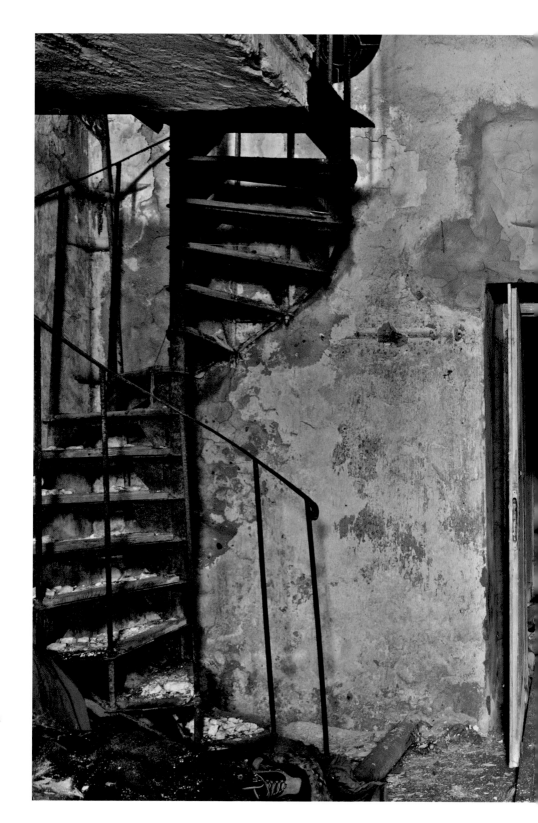

MIKVAH Bardejov, 2007

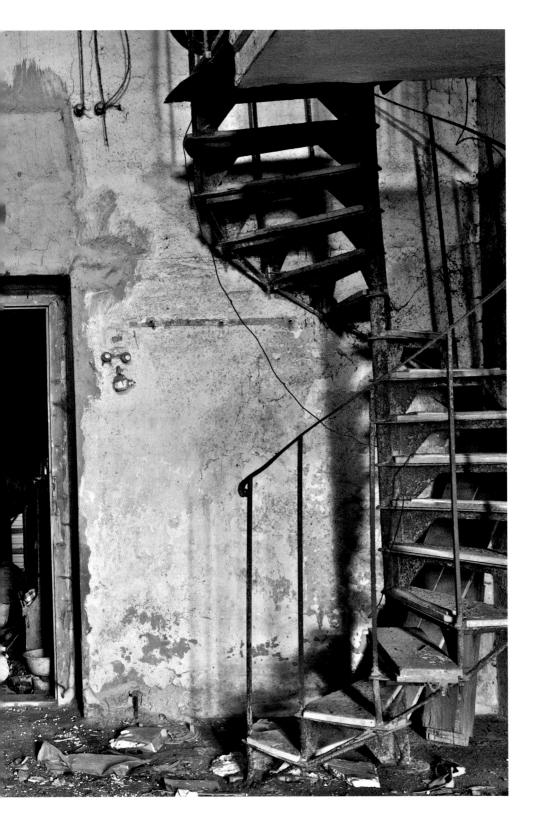

SYNAGOGUE Pečovská Nová Ves, 2007
SYNAGOGUE Lučenec, 2010

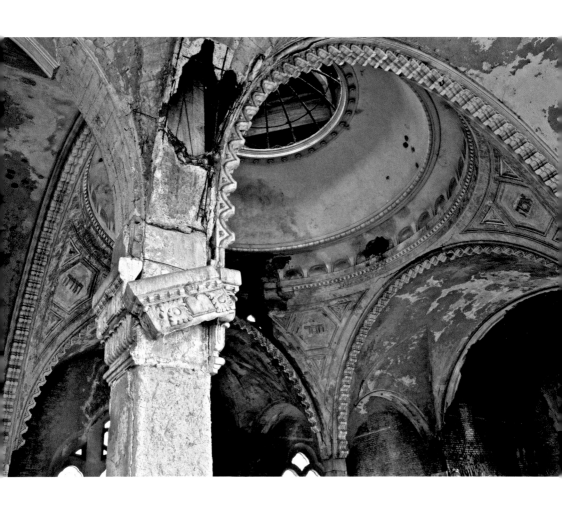

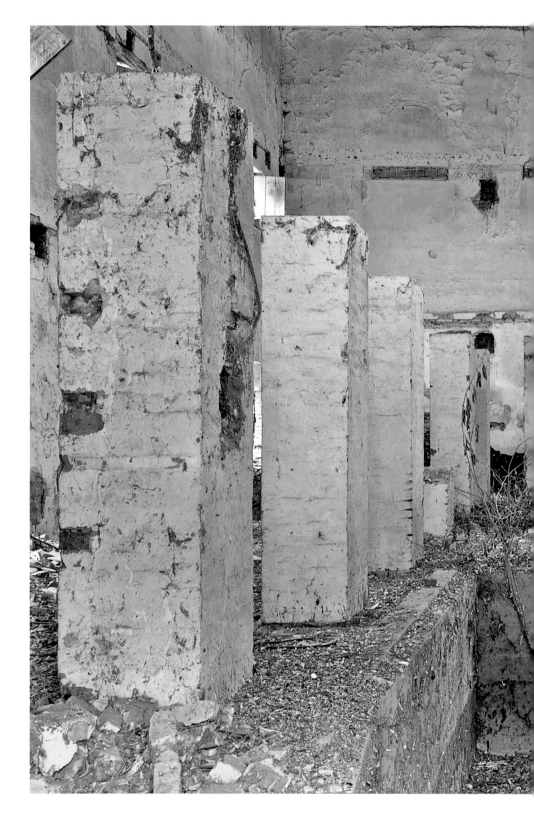

SYNAGOGUE Šaštín, 2007

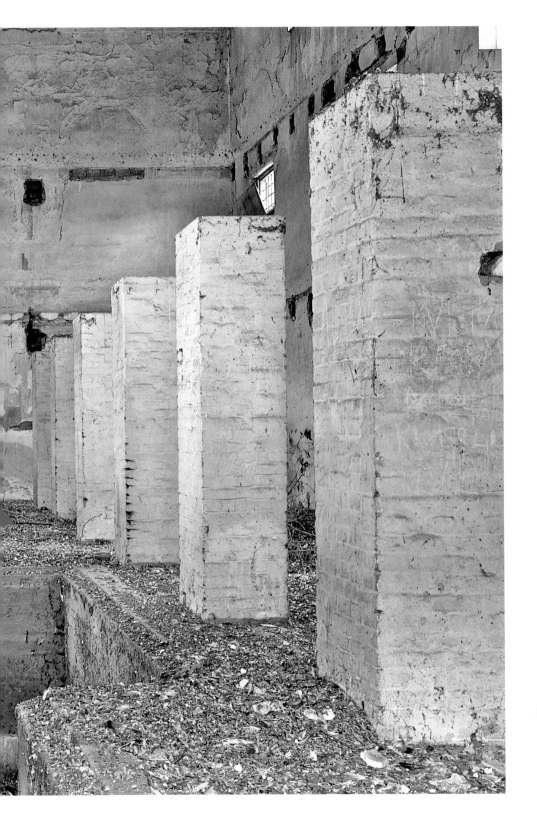

67

SYNAGOGUE Kraľovský Chlmec, 2006

PAGES 70–71

SYNAGOGUE Košice, 2006

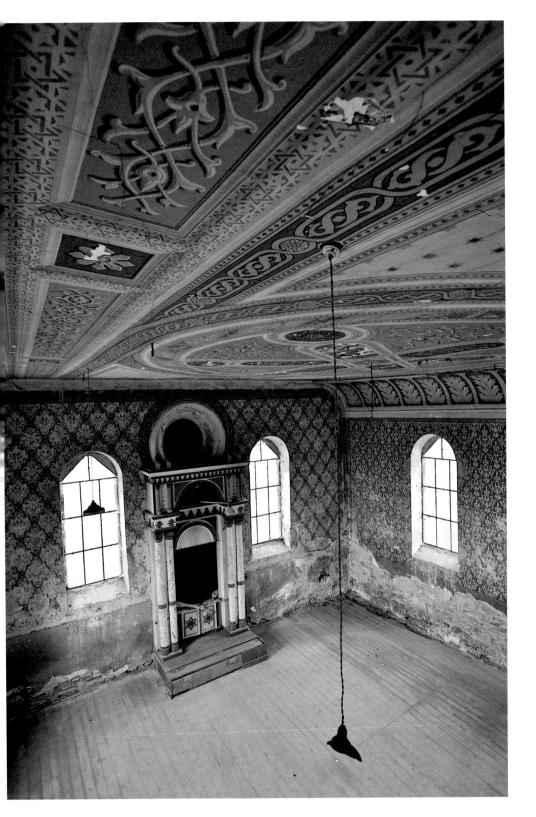

69

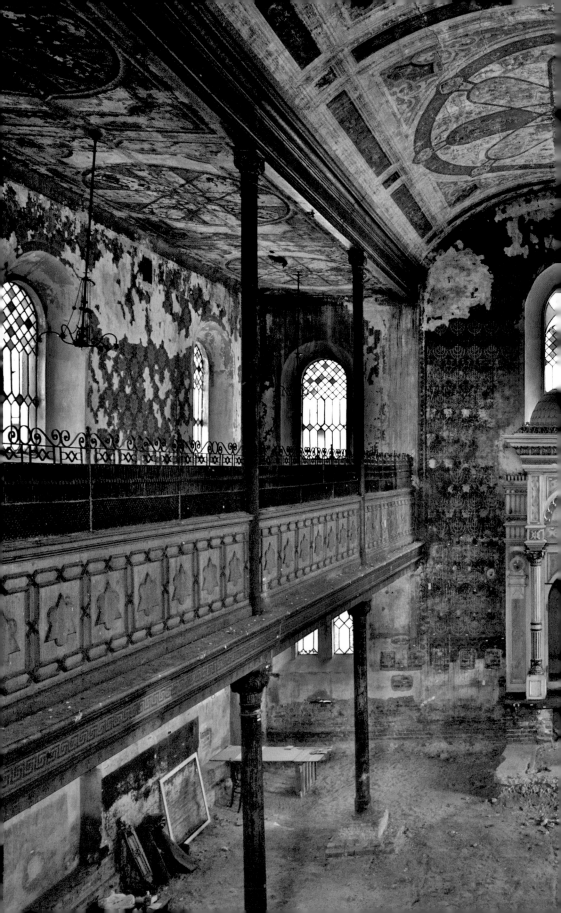

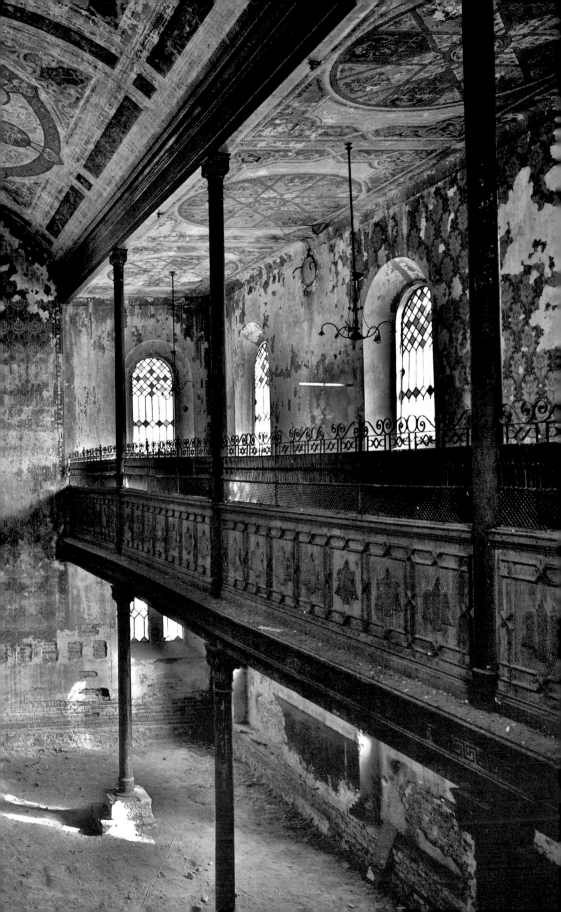

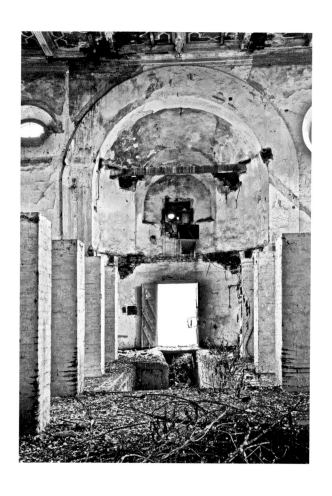

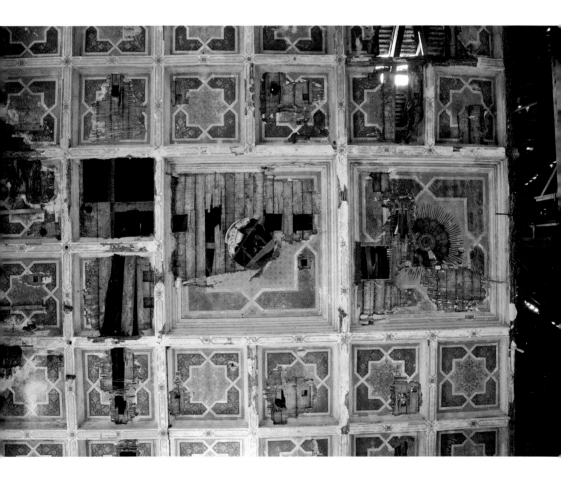

CEMETERY Čerhov, 2006

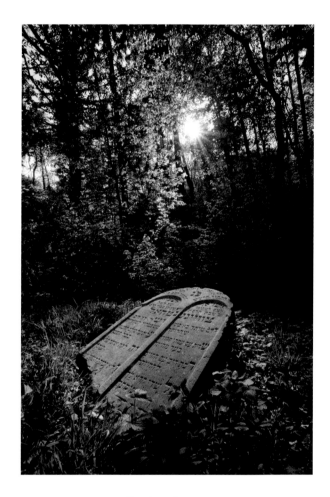

CEMETERY Klátová Nová Ves, 2007

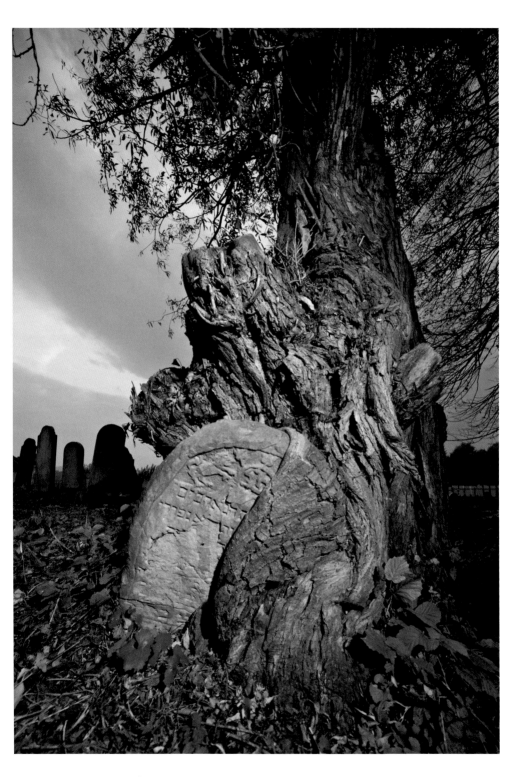

CEMETERY Bardejov, 2006

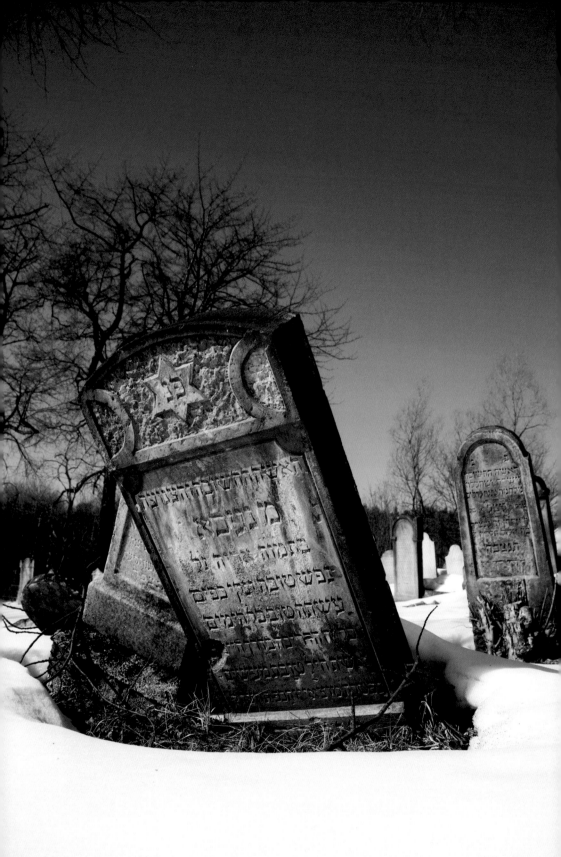

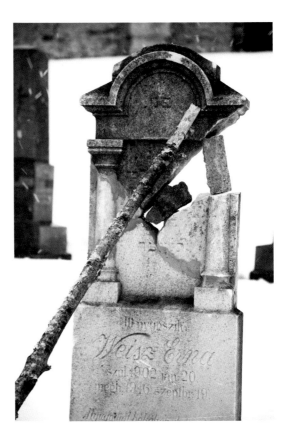

79

LUCIA FALTIN

It is believed that Jews first came to what is now Slovakia as slaves brought there by Roman soldiers from Judea in the second century. Under Hungarian rule from the tenth century, the area became a crossroads for Jewish cultural and ethnic groups, with largely urban Ashkenazim arriving from the west and more traditional Hasidim migrating from the shtetls of neighboring Galicia, a part of Poland and Ukraine, to the east. Nineteen centuries of relations between Jews and their non-Jewish neighbors reflected local developments and broader processes in Europe — from religious wars, through emancipation, to the rise of nationalism. The centuries saw times of flourishing coexistence, loyalties, and recognition, but these had often been counterbalanced by mutual suspicion and fear.

Within this context, the establishment of Czechoslovakia on 28 October 1918 was met with unease among the Jews, largely because they faced a new socio-political situation, something which inevitably brings with it, at least temporarily, a destabilization of the social order. Furthermore, a declaration of national independence is often accompanied by euphoric public manifestations — with violence often not too far from the festivities. The early days of Czechoslovakia proved no exception, and attacks on Jews and their property were part of extremists' attacks against the non-Slovak population, such as the Hungarians and the Germans.

In the first Czechoslovak Republic, Jews were among the smaller minorities. The Constitution of 1921 recognized Jewish ethnicity. In the 1921 census, nearly 73,000 people declared their ethnicity as Jewish, while over 136,000 identified their religion as Jewish, with some who declared themselves Jewish by religion, identifying themselves as Slovak, German, or Hungarian. Jewish support for the new Republic grew rapidly because of the efforts of Jewish leaders as well as those of the Czechoslovak government led by

81

the liberal humanist president, Thomas Masaryk. The development of Czechoslovak constitutional patriotism exacerbated tensions within the Jewish community. While national emancipation was supported largely by the Reform Jewish intelligentsia, Orthodox Jews considered emancipation to counter the core principles of Judaism. The year 1922 saw the founding of the first Czechoslovak Federal Zionist organization. A year later, the Jewish National Fund purchased land in Palestine where the first Czechoslovak settlement, Nuris, was built. Following the lead of their British counterparts, the Women's International Zionist Organization (WIZO) was founded in Czechoslovakia in 1925.

The Jewish population of Slovakia joined Czechoslovakia with the legacy of equal rights granted to them by the Hungarian parliament in 1895. This completed, as Slovak sociologist Peter Salner says, the opening of Jewish ghettos, a process that began in 1782 with the Edict of Tolerance of Austrian Emperor Josef II following his Tolerance Patent of 1781. The Patent was originally intended to bring equal civic rights to the Empire's non-Catholic Christians, but it also included clauses pertaining to the legal status of Jews that increased their social and economic freedoms. From 1840 the Jews of Greater Hungary were allowed to settle in the cities; this marked the beginning of the urbanization of what had been a largely rural Jewish population. As Jews moved to the cities in Slovakia, they became involved in business and industry, particularly in trade with major cities such as Vienna and Budapest. Besides Yiddish, the language spoken by Jews who moved to Slovakia from eastern Poland, urban Jews quickly acquired German and Hungarian, which, rather than Slovak, became their main languages.

Jews gradually assumed civic responsibilities at all levels of society. For instance, it was a common practice in the Slovak town

Topoľčany that the mayor, usually from the nationalist Hlinka Slovak People's Party, regularly attended festivities on the Jewish high holidays and had a Jew as his deputy. In smaller towns and villages, Jews and Christians often participated in each other's social and religious life. The increasing tolerance among Jews and non-Jews led to a gradual assimilation among Jews. By the mid-1930s, more and more Jews used the Slovak language, compared to the early days of the Republic. Although Jewish communities became relatively well integrated into the life of their country, they retained a significant degree of cultural identity. Their separateness often caused unease among the Slovaks, who felt that Jews did not participate sufficiently in common cultural and social activities. This unease increased rapidly by the end of the 1930s, when Slovak nationalists called for national unity on ethnic and cultural grounds.

The great economic depression didn't spare Czechoslovakia. While the Czech Lands were highly industrialized, having inherited from the Monarchy the most advanced industries which were further developed after 1918, Slovakia remained primarily agricultural. Economic deprivation led to attacks on Jews and others who were seen as exploiting the local population.

The declaration of the Slovak Republic in 1939 opened a new, fatal chapter in Slovakia's Jewish life, defining perhaps the most traumatic part of Slovak historical memory. Under the president, Jozef Tiso, a Roman Catholic priest, Slovak official policy followed the Nazi model. From March until October 1942, nearly 60,000 Jews were deported, most to their deaths. There followed a lull in the deportations until a popular uprising in August 1944, after which German forces moved in and engaged in a hunt for the Jews who remained. A number of political and Church leaders distanced themselves from the persecutions especially those involving Jews who had converted to Catholicism. The lower clergy and wider

public took the most active part in the rescue efforts. Nearly 500 non-Jews from Slovakia are recognized as Righteous among the Nations at Israel's Yad Vashem, one of the largest national groups by overall population size.

The end of Nazism and fascism did not bring an end to anti-Semitism in theory or practice. The gradual subjection of Czechoslovakia to the Soviet grip brought further persecution to its people. Jews were among the prime targets from the early post-war pogroms to the show trials of the early 1950s. Katya Krausova's father was among those targeted, although he was fortunate not to have been among those executed. The popular unrest in the 1960s that culminated in the Prague Spring was suppressed by the Soviet-led invasion in August 1968. It sent thousands of people into emigration, including Yuri Dojc and Katya Krausova.

Emigration, combined with limitations to civic liberties and religious freedoms, further reduced the already diminished Jewish communities in Slovakia. The fall of the Berlin Wall brought an end to the communist regime and launched a revival of civic, religious, and cultural life in Slovakia, which applied also to its remaining 3,000 Jews.

The past twenty years have not, however, brought a lasting paradise for the people of Czechoslovakia. Once again independent in 1992, Slovakia was subjected to the rule of the national-socialist government of Vladimir Meciar in the mid-1990s. The early restitution of Jewish properties, in which Slovakia prided itself, was soon countered by the neo-Stalinist persecution. The post-communist period also led to the rise of nationalism, reminiscent of the romantic nationalism of the 1840s. When the need to heal the amnesia of national memory caused by four decades of communism was most acute, the regime chose, instead, to

politicize national memory in support of the growing nationalism. The period between 1993 and 1998 triggered new waves of emigration by the intelligentsia, including many Jewish young people, who opted for higher education abroad. Fortunately, the brain drain was not to last permanently. Jews together with non-Jews created a strong civic alliance that ended Meciar's regime in 1998. The civil society that emerged outlived his administration and now serves as a solid platform that can withstand the inevitable and natural turbulence that arises from civic coexistence. The Holocaust, communism, and 'Meciarism' created black holes in Slovakia's historical and cultural memory. Today, it is largely because of civic initiatives that the troubled memory is examined in an attempt to come to terms with the past.

Judaism teaches respect for sacred books, which should not be burned, discarded, or otherwise destroyed, but must be ritually buried. The books of the Last Folio may have seemed to be awaiting burial, but their destiny has turned out differently. In a Platonic manner, they leave a permanent imprint on our memory, demanding that we revisit them frequently. In Genesis it is written "dust thou art, and unto dust shalt thou return." Instead of letting these books turn to dust, Yuri Dojc has transformed them into a Tree of Life, from whose roots comes the memory that feeds the branches of knowledge and wisdom. With their commitment to the preservation of cultural memory, Yuri Dojc and Katya Krausova provide water to the Tree of Life, nourishment to wisdom, and food for thought. Because of their sense of responsibility, these books belong forever to the library of universal wisdom.

SURVIVORS /

ALEXANDER SINGER Bratislava, 2005

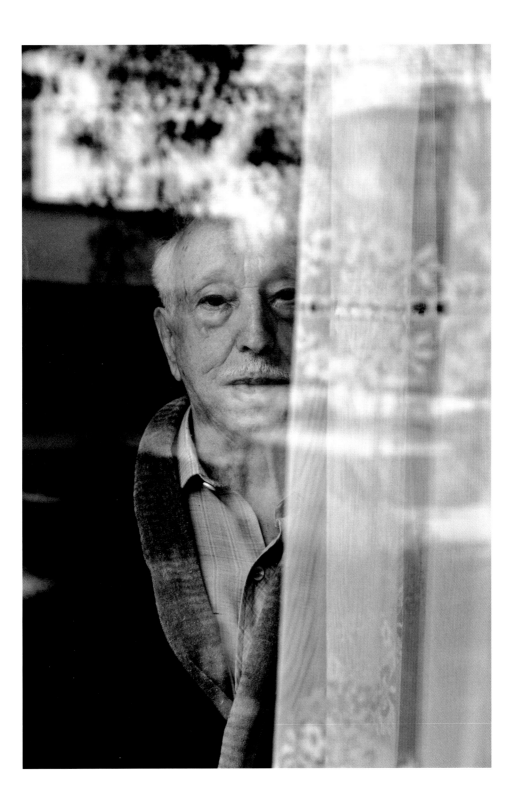

EVA GERLICKÁ Bratislava, 1998

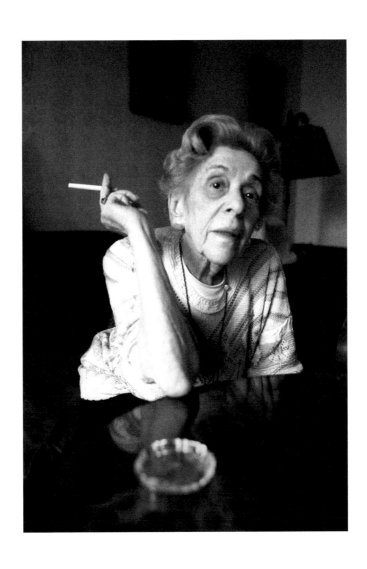

KLÁRA JESENSKÁ Nové Mesto, 1998

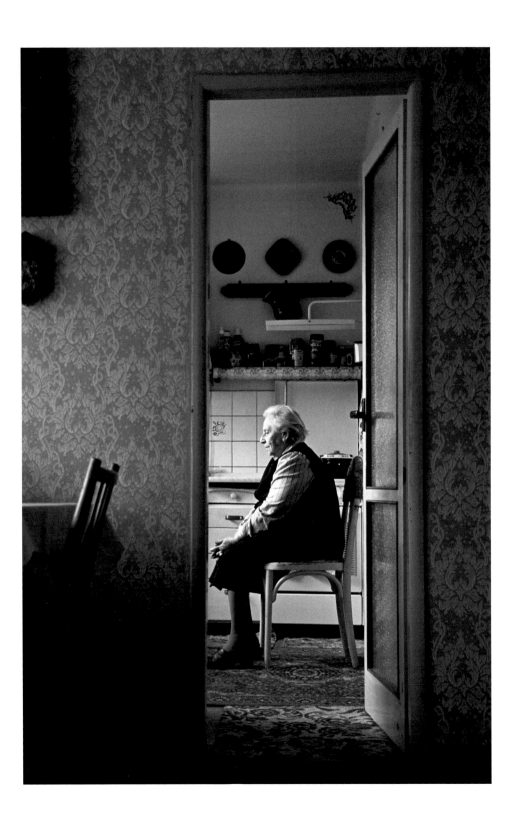

KAROL FISCHER Trenčín, 2004

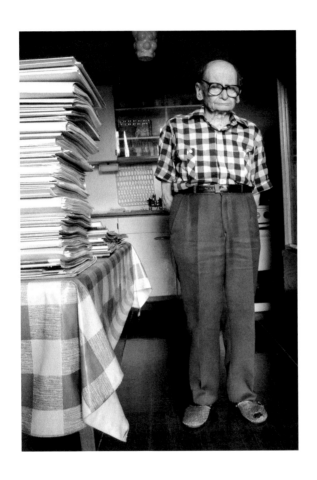

REGINA DOJČOVÁ Bratislava, 1998

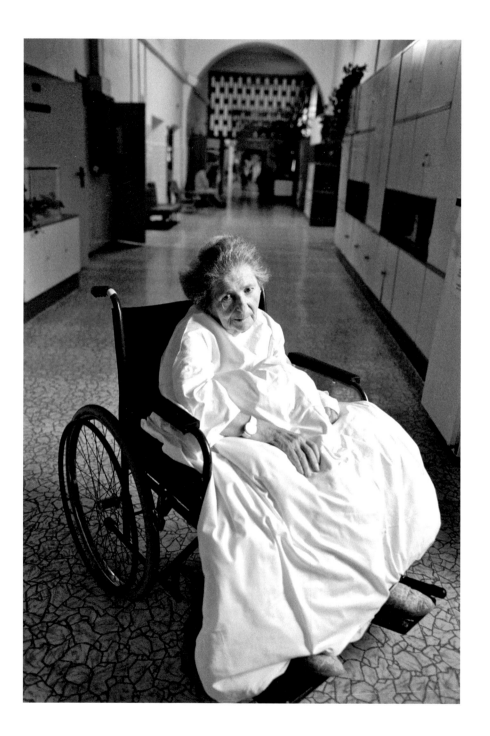

BERNÁT KNEŽO SCHÖNBRUN Bratislava, 2006

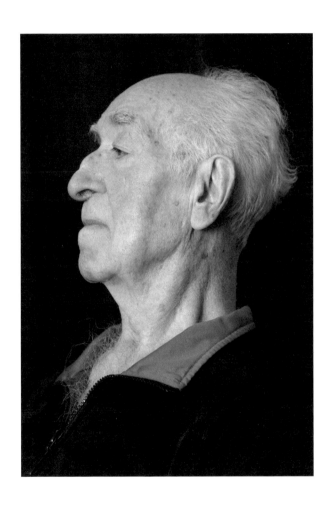

ALICA URBANOVÁ Piešťany, 2004

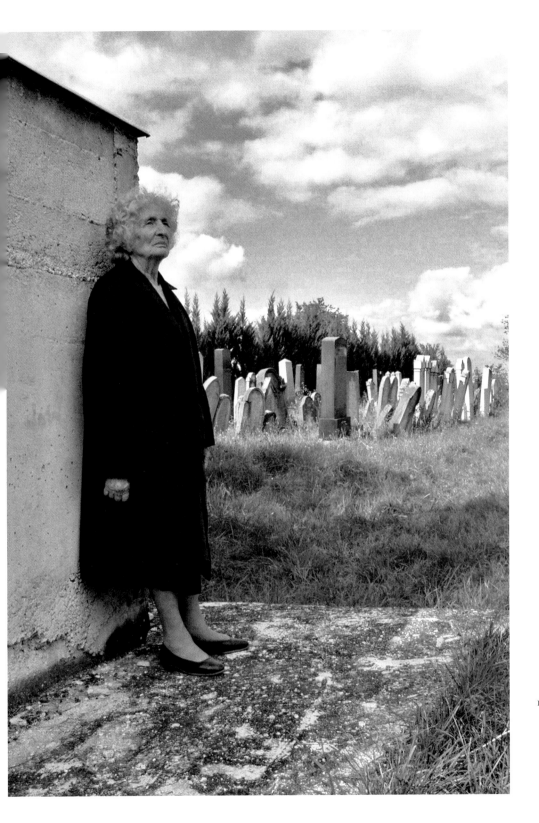

FERDINAND BLAU Bratislava, 2000

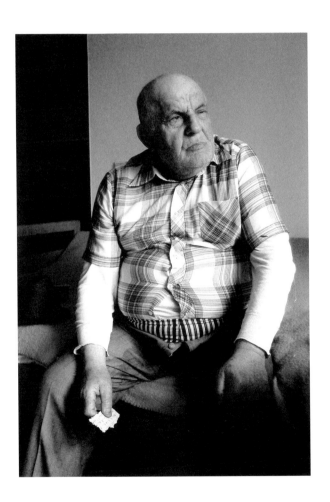

PRISKA LOMOVÁ Bratislava, 1998

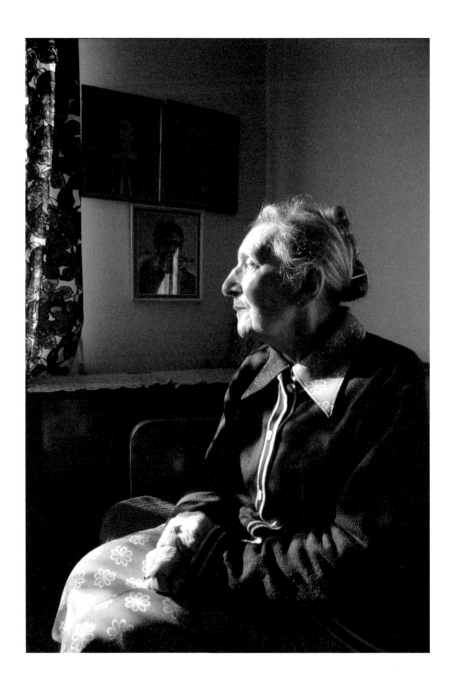

JAN PUŠKÁŠ Bratislava, 1997

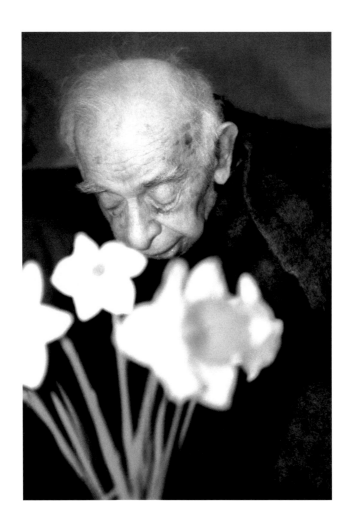

OLGA GALY LÖRINCZOVÁ Bratislava, 1997

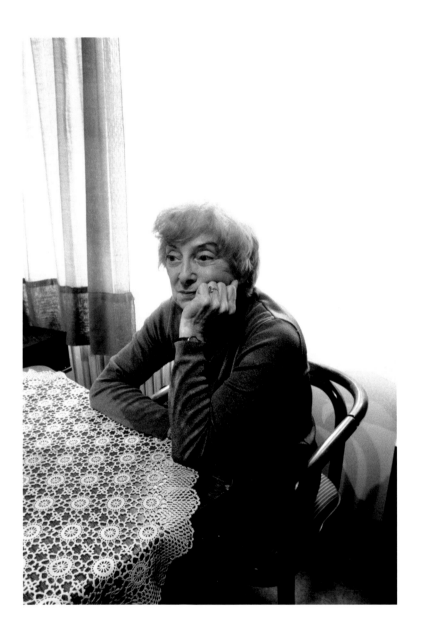

ELEMÉR HAAS Galanta, 2004

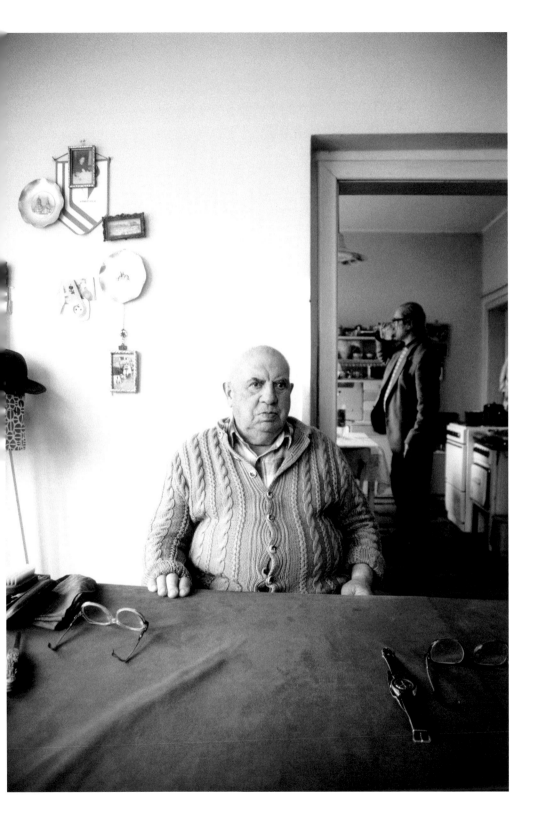

BERTA ŠIMONOVIČOVÁ AND KAROL ŠIMONOVIČ
Bardejov, 2006

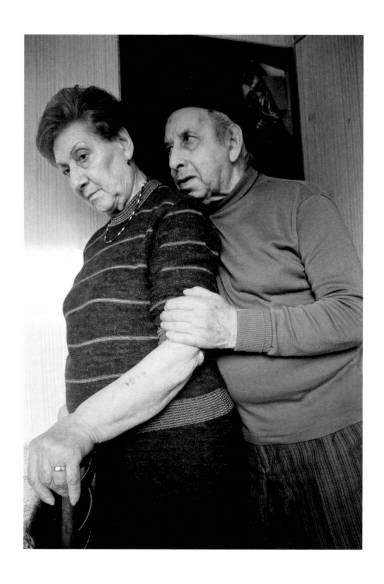

ADOLF SCHULTZ Bratislava, 2003

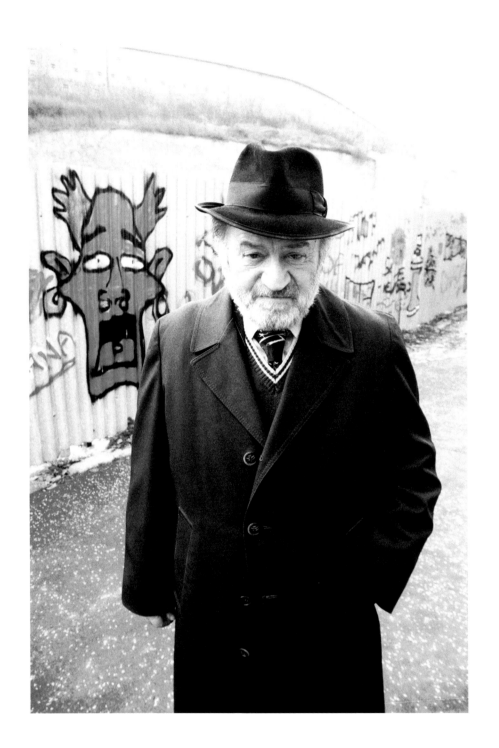

MARTA BELANOVÁ Bratislava, 1998

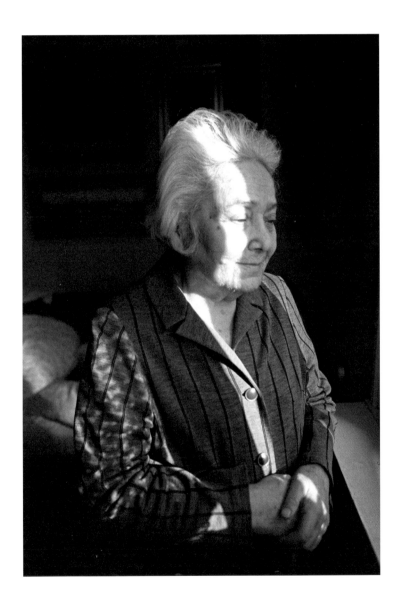

JEWS IN SLOVAKIA: A CHRONOLOGY

EARLY SETTLEMENT /

2nd century CE

Jews probably arrive in what is now
Slovakia, brought there from Judea as slaves
by Roman soldiers, although there are no
documented references to Jewish life until
the 11th century.

HUNGARIAN RULE /

10th century

Slovakia becomes part of the Kingdom
of Hungary (and remains so until 1918).

The benevolent policies of the Arpad Dynasty
(896–1301) attract Jewish emigrants
from western Europe and bring a period
of relatively peaceful coexistence.

11th century

Jews create communities in Bratislava,
Nitra, and Trnava. There is severe persecution,
particularly in Bratislava, during the
First Crusade.

13th century

Jewish lives are lost in massacres related to
the crusades and the Tartar invasion.
Following the devastation, foreign settlers,
including Jews, are invited to resettle in
the country and are granted the same rights
as the rest of the population.

14th and 15th centuries

Periods of full civic rights for Jews alternate
with expulsions and severe restrictions,
for example, on the type of clothing worn.
State policy is often linked to the financial
needs of the current ruler.

1526

Battle of Mohács. Ottoman forces defeat
the Hungarian army. Jews are expelled from
a number of towns and move to rural
areas where they live peacefully with the
non-Jewish population.

THE HABSBURGS

16th century

Under the early Habsburgs, the quality of Jewish life deteriorates with pogroms and blood libels.

1599

Count Pálffy acquires Bratislava castle and in the following years he resists the city's pressure to expel Jews from the castle area.

17th century

A new wave of Jewish immigration to Slovakia is supported by Hungarian landlords. Jewish schools and places of worship open.

Jews move beyond the castle area into the city of Bratislava and build synagogues and educational and cultural institutions.

1782

The Edict of Tolerance of Joseph II, granting religious freedoms and civic liberties, is extended to Jews.

18th–19th centuries

Thriving yeshivot in several Slovak cities attract students from all over Hungary and elsewhere in Europe.

1806

The Chatam Sofer becomes Rabbi of Bratislava. In response to his conservatism, the Reform movement is strengthened.

The first Jewish secular school, the Primärschule, opens.

1831

A cholera epidemic results in anti-Jewish riots in eastern Slovakia.

1840

Freedom is granted to Jews to buy land and to settle in royal towns.

1848–49

The Spring of Nations sees revolution spread through Hungary, followed by a war of independence against Habsburg rule. Patriotic Jews enlist in the army to support the Hungarian revolution. Anti-Jewish riots break out in western and central Slovakia.

THE AUSTRO-HUNGARIAN MONARCHY

1867

Establishment of the Austro-Hungarian Monarchy whose main aim is the assimilation of minorities. Hungarian becomes the official language of administration and education. Jews are encouraged to participate in commerce, finance, and industry. This leads to the liberalization of Jewish life and changes the dynamics of the conflict between Orthodox Jews and reformers, to the benefit of the latter.

Jews are granted full civic rights.

1860s and 1870s

The Magyarization of the Jews and their support for Hungarian national interests leads to a clash between Jews and Slovak nationalists. A Hungarian General Jewish Congress is convoked, following which the community officially splits into three denominations: Neolog, Orthodox, and Status Quo Ante.

Late 19th century

Zionism finds active support and a number of Zionist congresses are held in Bratislava. The Zionist movement intensifies the Orthodox-Reform controversy.

THE CZECHOSLOVAK REPUBLIC

28 October 1918

Founding of the Czechoslovak Republic.

1919

The Congress of Jewish Councils in Prague prepares the ground for the establishment of a Jewish Party and a National Federation of Slovak Jews.

1920

A new constitution recognizes Jewish ethnicity. Jews gradually assume civic responsibilities at all levels of society.

1921

According to the first Czechoslovak population census, nearly 136,000 people consider themselves Jewish by religion and 70,500 Jewish by ethnicity. Of the existing 217 congregations, 165 are Orthodox. There are 77 Jewish primary and two secondary schools and four yeshivot.

1923

The Jewish National Fund purchases land in Palestine and the first Czechoslovak settlement, Nuris, is built.

1925

The Women's International Zionist Organization is founded in Czechoslovakia and continues to operate even during WWII when its members are involved in Jewish rescue efforts.

1929

The Jewish Party gains two seats in Parliament.

Late 1930s

The Nationalist Youth Movement holds anti-Jewish demonstrations.

FASCIST SLOVAKIA: THE WAR YEARS

1938

Following the Munich Conference, the Prague government is compelled to grant autonomy to Slovakia. The Slovak People's Party seizes power, establishing a quasi-Fascist regime.

1939

A Slovak Republic is declared. Jozef Tiso, a Catholic priest, becomes head of what is effectively a German puppet state. Hungary seizes territories which include Dunajska Streda, Nové Zámky, Komárno, and Košice. Germans occupy the Czech lands.

18 April 1939

The first anti-Jewish law excludes Jews from government positions and service. Many more discriminatory laws follow.

August 1940

All Jews are required to register and to declare their financial status.

November 1940 Slovakia joins the Axis powers.

December 1940

A census indicates that there are approximately 89,000 Jews in Slovakia.

September 1941

Jews are required to wear a yellow Star of David and to serve in forced labor divisions established near Sered, Novaky, and Vyhne.

March–October 1942

The Slovak government promises to pay the Germans 500 marks for every Jew deported. From transit camps in Žilina, Novaky, Michalovce, Sered, Poprad, and Spišská Nová Ves, Jews are deported to German camps, mainly to Auschwitz, where only 300 survive, although around 6,000 manage to escape to Hungary during the deportations and others live in hiding.

Autumn 1942

As reports of the mass murder of Jews reach Tiso's government, the president refuses to hand over the remaining 24,000 Slovak Jews to the Germans.

August 1944

Underground resistance organizations revolt against the Tiso regime in the Slovak National Uprising; 1,600 Jews fight in this force.

German troops move in to quell the uprising and deport another 12,600 Jews, about half of whom die in the camps.

April 1945

Soviet forces occupy Slovakia and the Czechoslovak government-in-exile arrives in the country. In all, nearly 70,000 Jews have been deported from Slovakia, and more than 60,000 of them have been murdered (105,000 including those in Hungarian-occupied territory). Many of the survivors emigrate. The nearly 500 Slovak non-Jews who helped Jews during the war are one of the largest groups later named Righteous Among the Nations at Yad Vashem.

1946

Tiso is tried for inviting the Wehrmacht to suppress the Slovak National Uprising, for crimes against humanity, and for destroying Czechoslovakia. He is found guilty and hanged.

COMMUNISM /

1948

The Communist party, including many Jews,
comes into power in Czechoslovakia.
Jews are among the prime targets both in
post-war pogroms and later in the show
trials of the early 1950s.

1968

The unrest culminating in the Prague Spring
is suppressed by a Soviet-led invasion
and thousands emigrate, including many Jews,
especially young people, among them.

POST-COMMUNISM /

1989

The fall of the Berlin Wall brings an end to
the Communist regime. Among several Jews
involved in the "Velvet Revolution" is
Fedor Gal, a leading figure in an organization
called "Public against Violence."

A revival of civic, religious, and cultural life
begins in Slovakia.

1991

A Czechoslovak Union of Jewish Youth
is established with the goal of preserving
Jewish culture and tradition among the
younger generation. It publishes a magazine,
Chochmes (now defunct).

SLOVAK INDEPENDENCE

January 1993

Slovakia gains independence after the
peaceful division of Czechoslovakia into two
separate countries.

May 1993

Rabbi Baruch Myers arrives in Bratislava,
the city's first rabbi since the departure
of Rabbi Elias Katz in 1968, and introduces
youth and educational programs.

October 1993

The first of two laws providing for partial
restitution of Jewish property claims is
passed. The second law is passed in 2003.

2002

Slovakia marks its first Holocaust
memorial day.

2002–2003

Jewish cemeteries in Levice, Košice,
and Zvolen are vandalized in a wave of
right-wing extremism.

2010

An estimated 3,000 Jews live in Slovakia,
half of whom belong to a Jewish community.
The largest community is in Bratislava,
followed by Košice.

BIOGRAPHIES

YURI DOJC

Yuri Dojc left Czechoslovakia in 1968 when Russian tanks rolled into Prague and settled in Toronto where he embarked on a four-decade journey from refugee to internationally acclaimed photographer. His work is included in the collections of the National Gallery of Canada and the Slovak National Museum. The Library of Congress in Washington recently acquired a number of selections for its photography collection. In 2001 he received the Medal of Honor from the Slovak Ambassador to the United States for *We Endured*, a series of portraits of Slovak Holocaust survivors. Dojc has been profiled in dozens of magazines around the world including *Communication Arts*, *Applied Arts*, and *Creativity*, and he has been the subject of feature stories on both Apple and Microsoft's websites. A journey to Rwanda resulted in a double-page spread in the French daily *Libération*.

In 2010 Dojc published his sixth solo book, *Honour*, which pays homage to Canadian World War II veterans, and a retrospective of his work was exhibited at Bratislava's Mirbach Palace. Dojc's Last Folio exhibit opened at the Museum of Jewish Heritage in New York City in March 2011. It is scheduled to travel subsequently to Indiana University, Bloomington, Indiana, and to the European Union Commission headquarters in Brussels. Plans are underway for future US exhibition dates as well as international showings in Germany, France, Israel, and Russia.

KATYA KRAUSOVA

Katya Krausova is a London-based independent television producer/director whose work has been broadcast on national television channels and screened at prestigious film festivals around the world. She arrived in Britain following the 1968 Russian invasion of Czechoslovakia. Educated at the London School of Economics and Oxford University, Krausova joined the BBC, where she produced programs ranging from international political investigations to profiles of well known artists and performers from Sir Georg Solti to the Royal Ballet. Following the fall of the Berlin Wall she worked throughout the former Soviet bloc countries and eastern central Europe. She is a co-founder of the leading UK independent film and television production company Portobello Pictures, which won the 1997 Best Foreign Language Film Oscar for *Kolya*. She divides her activities between media management consultancy and documentary work such as *Last Folio*.

AZAR NAFISI

Azar Nafisi is best known as the author of *Reading Lolita in Tehran: A Memoir in Books*, a compassionate and often harrowing portrait of the Islamic revolution in Iran and how it affected one university professor and her students. The book spent over 117 weeks on the *New York Times* bestseller list, has been translated into 32 languages, and has won numerous literary awards. Nafisi is a visiting professor and the director of Cultural Conversations at the Foreign Policy Institute of Johns Hopkins University's School of Advanced International Studies in Washington, D.C., where she is a professor of aesthetics, culture, and literature and teaches courses on the relation between culture and politics. She has held a fellowship at Oxford University and has taught at the University of Tehran, the Free Islamic University, and Allameh Tabatabai. Her book *Things I Have Been Silent About: Memories* was published in 2009.

LUCIA FALTIN

Lucia Faltin came to the UK from Slovakia in 1999 and is Director of International Programs at the Cambridge-based Woolf Institute, dedicated to the interdisciplinary study of relations between Jews, Christians, and Muslims. Her primary interest is in the role of religion in the public square and in international relations, with particular emphasis on European integration and conflict prevention. She is also pursuing doctoral studies in religion and secularism at the University of Cambridge. Having dedicated fifteen years to interfaith work in theory and practice, she served, inter alia, on the executive board of the International Council of Christians and Jews and co-founded the History of European Integration Research Society. She co-edited (with Melanie J. Wright) *The Religious Roots of Contemporary European Identity* (2007, 2010), and is editor of the newsletter *Perspectives* published by the Woolf Institute.

DANIEL WEIL

Daniel Weil, architect and designer, studied architecture in Buenos Aires and industrial design at the Royal College of Art, London. He was unit master at the Architectural Association and professor of Industrial Design, Vehicle Design, and Design Management at the Royal College of Art. He is a senior fellow of the Royal College of Art. As a student in 1981 he designed the Bag Radio, which is included in many permanent design collections including the Museum of Modern Art, Victoria & Albert Museum, and Design Museum. In 1992 Weil joined Pentagram as a partner and has worked there on a wide spectrum of projects — corporate, cultural, and personal. These include the re-design of the interior of the new Archaeological Wing of the Israel Museum in Jerusalem, opened in July 2010, and airplane beds and airport environments for United Airlines. Weil was art director for the Milan lab of Swatch and designed the packaging for Irony watches and for their shops and flagship store in New York. His design of the CD packaging for the Pet Shop Boys albums *Very* and *Very Relentless* received a Grammy Nomination.